G000243614

BY STEAMER TO THE SOUTH COAST
Andrew Gladwell

AMBERLEY PUBLISHING

Acknowledgements

This book has been written to evoke the heritage and atmosphere of the well-loved pleasure steamers that plied their trade along the south coast from resorts such as Brighton, Bournemouth, Weymouth and Swanage. In compiling this book I have been grateful for the help and cooperation of several individuals. In particular, I would like to thank Eric Cross, John Bamber, David Jones and Kieran McCarthy.

To find out more about pleasure steamers visit these websites:

For details of paddle steamer heritage visit www.heritagesteamers.co.uk
For details of the paddle steamer *Waverley* visit www.waverleyexcursions.co.uk
For details of the Paddle Steamer Preservation Society visit www.paddlesteamers.org
For details of the motor vessel *Balmoral* visit www.balmoral.org.uk
For details on the paddle steamer *Kingswear Castle* visit www.dartmouthrailriver.co.uk

First published 2014

Amberley Publishing
The Hill, Stroud
Gloucestershire, GL5 4EP

www.amberley-books.com

Copyright © Andrew Gladwell, 2014

The right of Andrew Gladwell to be identified as the Author of this work has been asserted in accordance with the Copyrights, Designs and Patents Act 1988.

ISBN 978 1 4456 1451 9 (PRINT)
ISBN 978 1 4456 1465 6 (EBOOK)

British Library Cataloguing in Publication Data. A catalogue record for this book is available from the British Library.

Typeset in 9.5pt on 12pt Celeste.
Typesetting by Amberley Publishing.
Printed in the UK.

Introduction

The south coast of England has seen pleasure steamer services flourish for close on 200 years. Paddle steamer services on the south coast only ever saw two main companies dominate services: Red Funnel and Cosens. Weymouth-based Cosens was formed in 1852, initially to operate services between Weymouth and Portland. The early years of the company saw the usual flurry of competition and new tonnage. Early steamers included *Highland Maid*, *Wave Queen* and *Prince*. Cosens had strong competition from John Tizard who operated *Premier* in direct competition from Weymouth. Competition increased when Tizard introduced *Ocean Bride* and *Contractor*. Eventually, in 1876, John Tizard joined Cosens. Such frenzies of competition were to a great extent beneficial to the expansion and enrichment of services as they ensured that competitors engaged new tonnage, increased passenger comfort and opened new routes. Inevitably, this usually resulted in the best steamers and routes surviving. This in turn would provide a firm foundation for the paddle steamer services that would thrive in the later Victoria era. One of the highlights of the mid-Victorian era for Cosens was the construction and entry into service of the *Empress*. Regal names became the norm for Cosens in subsequent years as *Monarch* and *Victoria* arrived. The era was also important in that Cosens' routes conveyed passengers from as far afield as the Channel Islands, Cherbourg and Torquay.

The Isle of Wight has always been central to the history of the pleasure steamer. In 1861, the longest-named and longest-surviving steamer operator commenced services when the Isle of Wight & South of England Royal Mail Steam Packet Company (commonly known as Red Funnel) was formed. The company's principal route was between Southampton and Isle of Wight piers, such as those at Cowes, Ryde and Yarmouth. This was the heyday of the Isle of Wight as the holiday and weekend home of Queen Victoria. Her frequent visits to Osborne House at Cowes made the Isle of Wight a fashionable place to visit. Red Funnel reacted to this by introducing suitably named steamers, and so *Her Majesty*, *Princess Beatrice* and *Princess Helena* entered service on the south coast during the 1880s to cope with increasing trade and increased passenger expectations. The 'Red Funnel' steamers, as they were to become known, experienced a relatively unchallenged early history between the Isle of Wight and the mainland. By the latter part of the Victorian era, the paddle steamer had developed to the point where the facilities, atmosphere, layout and size were more or less set for the next decade or two.

By the time of Queen Victoria's Diamond Jubilee in 1897, the paddle steamers of the south coast were at perhaps their zenith. They were more plentiful, larger and more luxurious than they had ever been or would ever be. The crowning moment was the impressive Spithead Fleet Review of 1897. The UK would never see such a spectacle again. The review showed the features and potential of the south coast to visiting paddle steamers from areas such as the River Thames and the Bristol Channel. A result of this was that P&A Campbell made an entry into south coast and Southampton services with the magnificent *Cambria* and *Glen Rosa*.

In 1900 Red Funnel placed the regally named *Balmoral* into south coast service in direct opposition to P&A Campbell's *Cambria*. Not to be outdone, and equally determined to have yet another regal name, Cosens placed *Majestic* in service in 1901.

The now invincible P&A Campbell fancied some of the receipts and expanded services to include the huge markets offered by major Victorian resorts such as Brighton, Hastings and Eastbourne. These usually connected with services at Southampton and Portsmouth, as well as further into Kent. Here, they took over steamers of the Brighton, Worthing & South Coast Steamboat Company. The Sussex coast had previously only seen modest exploitation of services. Although Brighton had developed at the time of the Prince Regent, its heyday was at the very end of the nineteenth century when the Palace Pier and West Pier developed into large seaside pleasure piers. Along with that went extensive facilities for landing paddle steamers. Similarly, the other main resorts of Eastbourne and Hastings developed paddle steamer services amid a sea of amalgamations and changes in the latter two decades of the nineteenth century.

By expanding a hitherto unexploited market, P&A Campbell would be offered a great deal of potential and could also base their operations in an area where there was a market. In 1902 the Brighton Company was purchased by P&A Campbell and the company set about transforming the fleet for their needs. The Sussex coast, with its extensive and exploited resorts, gave them the perfect operating area. Fine piers and landing facilities had been built and the geographical position of the resorts meant that the company could run services to and from areas such as the Isle of Wight, Southampton, Bournemouth, Southsea, Deal and Folkestone, as well as trips to Boulogne and Cherbourg. The densely printed handbills of the period show the sheer ambition of the company as well as the potential of the area. At the time, *Brighton Queen*, *Bonnie Doon* and *Glen Rosa* undertook the cruises. The most exciting and longest cruises of all were the delivery and return cruises at the start and end of each season from the Bristol Channel to the Sussex coast.

Southampton services were invigorated at this time by the arrival of new steamers. One of the earliest of these was the *Princess Royal* of 1906. The summer of 1908 witnessed the arrival of one of Bournemouth's most well-loved steamers when the *Bournemouth Queen* entered service. Further changes came when Cosens placed the *Emperor of India* in service in 1908.

The Edwardian era on the south coast was therefore a period of change. Companies disappeared while others combined to provide a leaner and less competitive arena of operation. This resulted in several steamers being withdrawn. *Brodick Castle*, as well as several others, plied the south coast for the last time. The last flurries of activity before the First World War saw steamers such as *Melcombe Regis* and *Alexandra* enter service for Cosens. These were welcome new additions, but weren't revolutionary new steamer tonnage.

After services during the First World War, south coast services were reinvigorated by the addition of new and somewhat similar tonnage during the 1920s. One of the greatest was the *Princess Elizabeth* of 1927, named after the young princess who would become Elizabeth II. The *Gracie Fields* was the last paddle steamer to be built for Southampton service, as motor vessels were to become the norm from the 1930s onwards. Cosens, though, still preferred paddle power, and in 1937 they acquired the *Duke of Devonshire* and renamed it *Consul*. She was soon joined by the *Embassy*.

In 1949 south coast services were enlivened when Red Funnel placed the order for one of their most famous and long-lived of all vessels: the motor ship *Balmoral*. *Balmoral* was built as a ferry between Southampton and Cowes but also carried out extensive excursion cruise work. Her design, facilities and seaworthiness was exemplary. The ex-*Queen of Kent* and *Queen*

of Thanet were also acquired and renamed by the company, but really weren't required as the post-war decline in passenger traffic had started.

Sussex coast services by P&A Campbell became an early casualty of the decline. By 1950 services were merely undertaken by the *Glen Gower*. The splendid new *Cardiff Queen* also made an appearance on the Sussex station in 1952 and 1953 before the *Glen Gower* returned to Brighton in 1956. Within a year P&A Campbell withdrew their service on the south coast. The position had certainly changed since the heady days of the fleet review for Queen Victoria's Diamond Jubilee some sixty years earlier.

Other pleasure steamers on the south coast were sold or withdrawn. This meant that post-war fleets were smaller and more reflective of new conditions. Inevitably, by the mid-1950s the post-war shrinkage of fleets was becoming more acute. Favourite steamers, such as the *Emperor of India* and *Bournemouth Queen*, were withdrawn in 1957. The Cosens and Red Funnel fleets became a pale reflection of their former selves. Luckily for Red Funnel, they had options for the future in the introduction of car ferrying. Red Funnel therefore started to change from carrying passengers to cars and, by 1965, *Balmoral* became the last Red Funnel excursion steamer.

After the Second World War Cosens resumed services much as they had done before. They were also lucky as they had suffered no losses. Withdrawals were made, but the post-war years were typified by the running of the three venerable old paddle steamers *Consul*, *Embassy* and *Monarch*. With post-war refits, all three steamers happily plied for Weymouth trade through the 1950s, despite the inevitable decline of services nationally. Sadly, *Monarch* was withdrawn in 1961. The delightful *Consul* followed in 1962 and just four years later in 1966, the final one, *Embassy*, was withdrawn.

By the late 1960s the position was made even worse when the *Ryde* was withdrawn from service. The three Portsmouth motor ships gallantly carried on the pleasure cruising tradition, but the variety and number of cruises of years gone by could never be repeated. The final straw was the withdrawal of the well-loved *Balmoral* of the Red Funnel fleet. She was the last of the Red Funnel pleasure steamers and provided the last pleasure cruises for the company. For many, it seemed that the tradition of coastal cruising on the south coast was more or less at an end. The 1970s saw south coast services sink to an all-time low.

By the late 1970s a new key player was emerging when the *Waverley* made her first visits south in 1978. She had been built for service on the Firth of Clyde and had entered service in 1947. By the early 1970s she was sold to preservationists for £1, and in 1975 embarked upon her preservation career. It was soon realised that the Firth of Clyde would only have limited potential as an area for cruising, so new markets were looked for further afield. The south coast provided excellent potential for *Waverley*. Soon, ports such as Southampton, Weymouth, Southsea and Hastings witnessed the arrival of a paddle steamer once again.

Another and perhaps more important event occurred in 1986 when the famous *Balmoral* of the Red Funnel fleet joined *Waverley* as her much-needed consort after many years of uncertainty. This was great news as one of the finest and most popular of all south coast pleasure steamers was operating again and providing the services that she was built for. Since that time *Balmoral* has continued the great tradition of providing cruises along the coastline of Dorset, Hampshire, Sussex and the Isle of Wight, thereby recreating the glory days of south coast pleasure steamers!

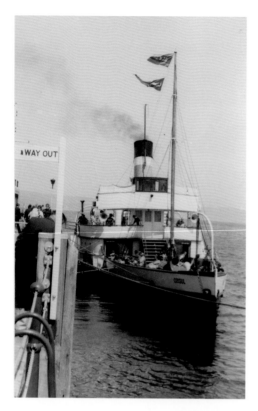

South coast pleasure steamers have provided spectacular cruising along the coastline of the Isle of Wight, Dorset, Sussex and Hampshire since the advent of services during the mid-nineteenth century. The best place to view the splendid scenery is from the deck of a traditional pleasure steamer.

The well-loved trio of *Embassy*, *Monarch* and *Consul* helped to keep the tradition of coastal cruising alive during the 1950s and 1960s. They provided spectacular cruises to see the splendid Dorset coastline, as well as trips to the Isle of Wight and Lulworth Cove.

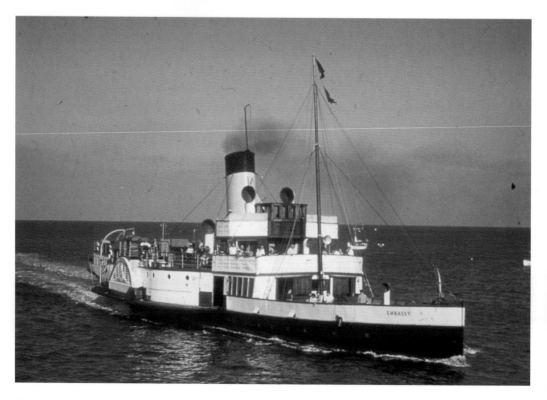

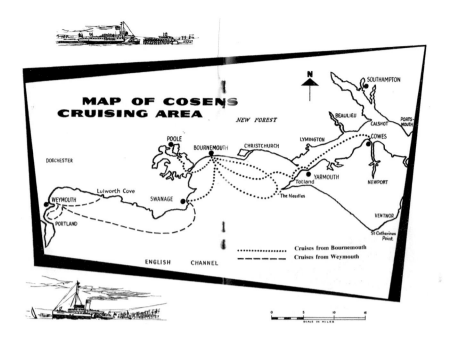

Map showing the principal cruising area on the south coast. The Solent, Dorset and the Isle of Wight and seaside resorts provided the main catchment area for passengers, but services also extended towards Sussex and Devon. The south coast provided a wide range of cruises that encompassed traditional seaside resorts, the spectacular coastal scenery of Dorset and the Isle of Wight, as well as the busy shipping areas of Southampton and Portsmouth.

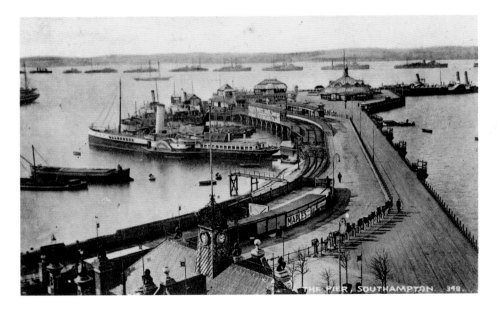

The Royal Pier in its heyday with a vast array of paddle steamers moored in every available berth. This view shows some of the large pier-head buildings that typified piers that hosted paddle steamers. Also note the advertising that was placed to attract the interest of passengers as well as the slot machines.

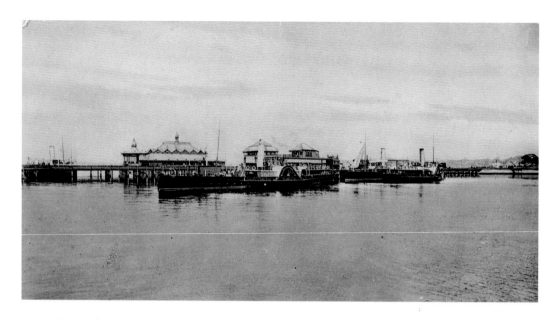

The Royal Pier at Southampton was designed by Edward Stephens and opened by the Duchess of Kent and Princess Victoria on 8 July 1833. A pontoon for steamers was added in 1864 and, just five years later, train lines were extended to the pier head where a station was erected. The pier underwent major reconstruction during the early 1890s and a splendid pavilion was built.

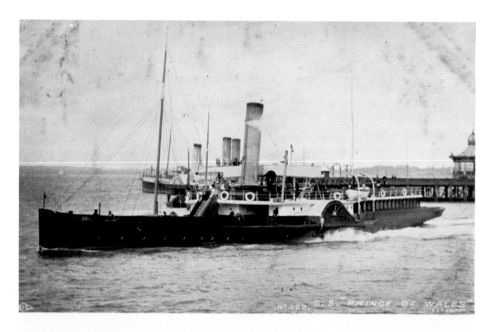

The *Prince of Wales* departing for the mainland, with *Balmoral* in the distance alongside the pier. The Isle of Wight was one of those rare areas in the UK where the paddle steamers were crucial for transporting people and goods from the mainland to the island. Good railway connections were provided, but the pleasure steamer crossed the water as bridges and tunnels couldn't be constructed.

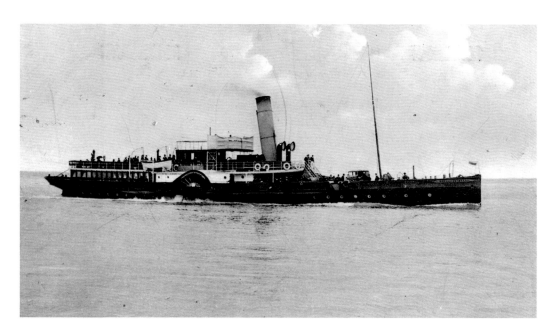

The *Duchess of York* during her Southampton and Isle of Wight heyday.

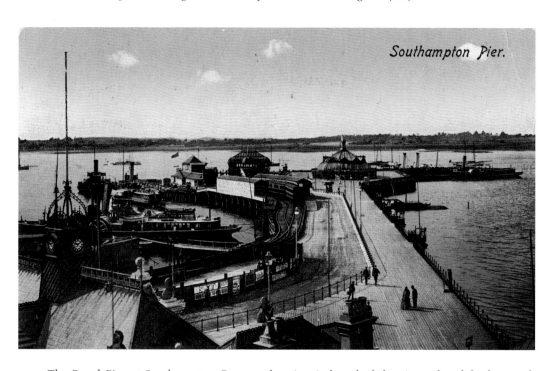

The Royal Pier at Southampton. By 1913 the pier timbers had deteriorated and further work was undertaken to make it safe, but trains were stopped from using it after 1921. After damage during the Second World War, the pier saw facilities enhanced in the late 1940s. The Royal Pier was finally closed on 2 January 1980 after engineers declared its maintenance to be economically unviable, after which the Royal Pier declined even further. One of the last pleasure steamers to use the pier was the famous *Waverley*'s consort, *Balmoral*.

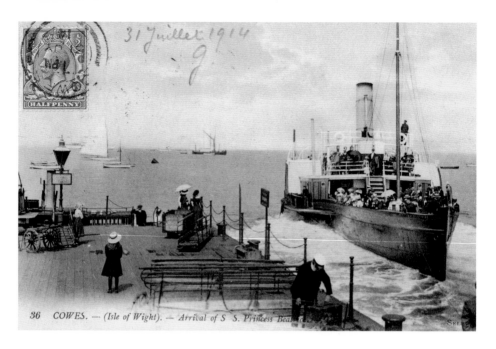

36 COWES. — (Isle of Wight). — Arrival of S S. Princess Beatrice.

Princess Beatrice departing from Cowes around 1902. She was built by Barclay Curle at Glasgow in 1880 for Red Funnel. She was 175 feet in length and was 253 tonnes. She served as a minesweeper during the First World War and re-entered peacetime service in 1919. She was withdrawn at the end of 1930 and was scrapped in 1933 at Northam.

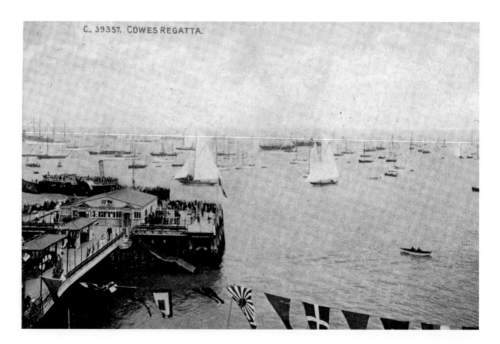

C. 39357. COWES REGATTA.

Cowes Regatta was very popular with passengers aboard paddle steamers, and special trips were arranged to take passengers to the busy event. Cowes was always a busy centre for the event and passengers enjoyed seeing members of the royal family aboard their yachts.

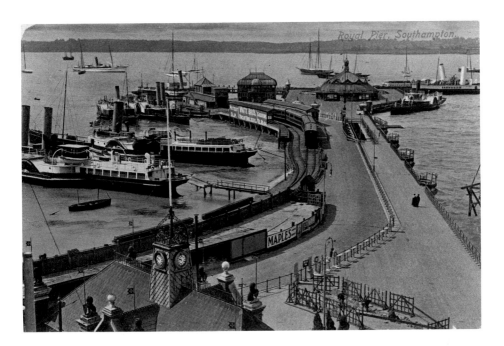

Red Funnel's *Queen* and *Princess Mary* at the Royal Pier, Southampton, during the heyday of the Red Funnel fleet. The pier was always a hive of activity as paddle steamers arrived and departed.

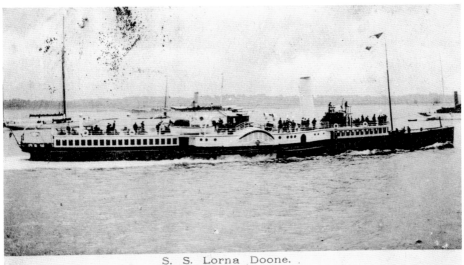

S. S. Lorna Doone.

S., I. of W., & S. of E. R. M. S. P. Co. Ltd. Fleet of Pleasure Steamers.
Balmoral, Lorna Doone, Princess Royal, Queen, Solent Queen etc.

Red Funnel's *Lorna Doone* was originally built for Bristol Channel service in 1891 and was sold for south coast service in 1898. She saw a number of visual changes, which included extra funnels, enlarged saloons and extending decks. Her funnel remained white, but later had a black top added. Finally, she received a red-and-black funnel in the 1930s. After the Second World War, she was old and surplus to requirements and was scrapped in 1946.

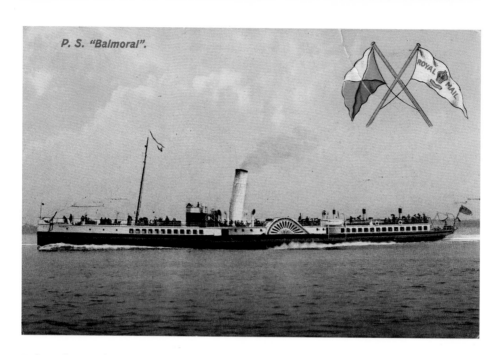

P. S. "Balmoral".

Balmoral entered service in 1900 at the time when P&A Campbell introduced their splendid *Cambria* on the south coast. She was a vast improvement on the many local paddle steamers that operated in the area at the time. When introduced, she had a white funnel that replicated the funnel livery of P&A Campbell.

Lorna Doone ran her first season for the Southampton Company with a yellow funnel. Soon after, she was re-boilered and the funnel colour was then changed to white. This funnel colour remained until 1931 when a black top was added.

Lorna Doone was built by Napier, Shanks & Bell in 1891. She was purchased by Red Funnel and looked a great deal like the Belle steamers of the east coast. She was scrapped at Northam in 1948.

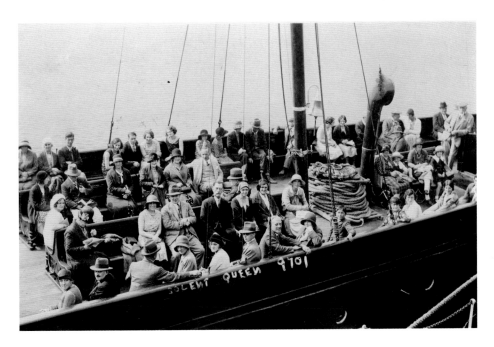

Passengers posing aboard the *Solent Queen* during the 1920s. In the days before cheap photography, people would have shots like this taken on the steamer as a souvenir of their day. They would usually collect the photograph at the end of the trip or day. These views always show a great deal of information on the layout of the decks as well as fashion of the times.

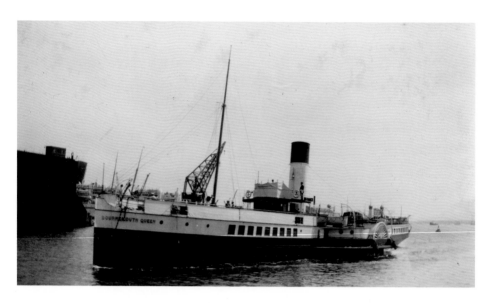

Bournemouth Queen was built by the well-known Ailsa of Troon yard in 1908. She became one of the most loved paddle steamers to ever operate along the south coast. She had a normal operating speed of around 15 knots and continued operating as a coal-fired paddle steamer until she was withdrawn in 1957.

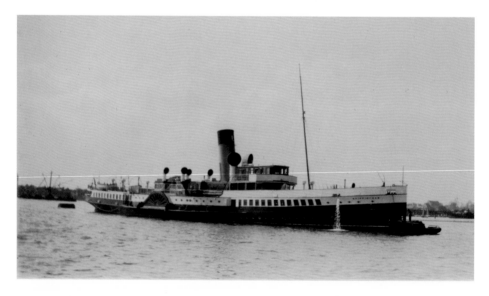

Whippingham was built by Fairfields in 1930 and soon after entered service for the Southern Railway. She was built along with the *Southsea* and they were the first paddle steamers to be constructed by the company in almost thirty years. *Whippingham* was a large steamer and reflected the growing trade at the time. At the time of her launch, she could carry 595 first-class and 467 second-class passengers. Her normal operation was from Portsmouth to Southsea and the Isle of Wight. She was coal fired and at times provided cruises to as far away as Weymouth as well as round the Isle of Wight. Towards the end of her career she lost a lot of her speed and operated at around 10 knots, which was a lot less than her original 16 knots. She was scrapped in May 1963.

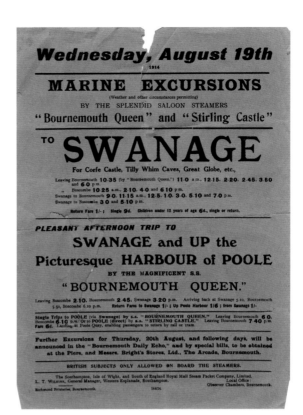

Handbill advertising cruises by the *Bournemouth Queen* and *Stirling Castle* to Swanage and Poole in 1914. The outbreak of the First World War caused a certain amount of hysteria regarding foreigners. Handbills and posters had notices added stating that any aliens wouldn't be allowed aboard the steamers.

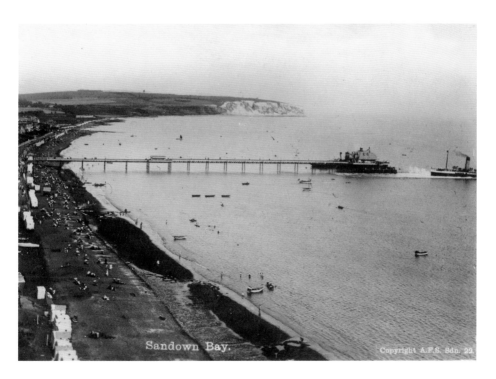

A Red Funnel paddle steamer drawing away from Sandown Pier.

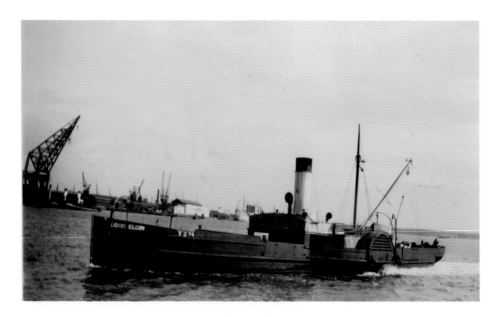

Lord Elgin was built by Richardson, Duck & Co. at Stockton on Tees in 1876. After initial service on the Firth of Forth, she sailed south for service on the south coast for the Bournemouth & South Coast Steam Packets Limited at Bournemouth. She was converted to carry cargo in 1910 and operated between Cowes and Southampton carrying cars and livestock at times. On some occasions this included elephants and other wild animals when circuses were visiting the island. She lasted a long time and was eventually withdrawn in 1955 when she was the last cargo paddle steamer in the UK.

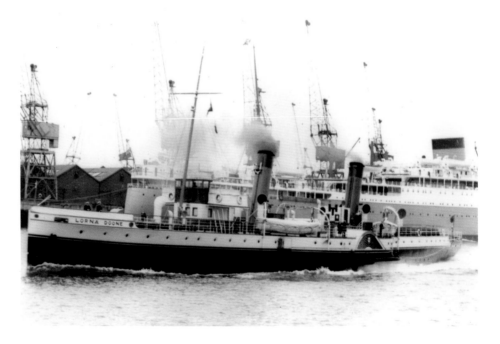

The post-war *Lorna Doone* passing ocean liners in Southampton Water. She had a distinctive look and her time as part of the Red Funnel fleet was somewhat limited.

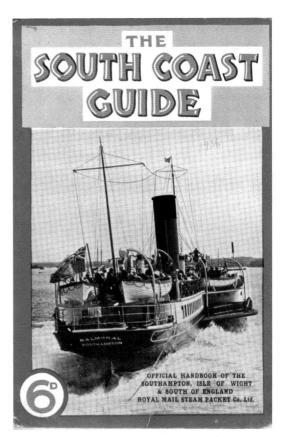

Cover for Red Funnel's handbook in 1936. Handbooks were sold for a few shillings to passengers around the decks.

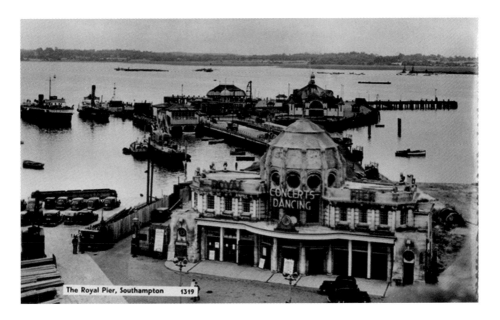

The Royal Pier at Southampton around the 1930s when motor vessels were being introduced to replace or work alongside the paddle steamers of the Red Funnel fleet.

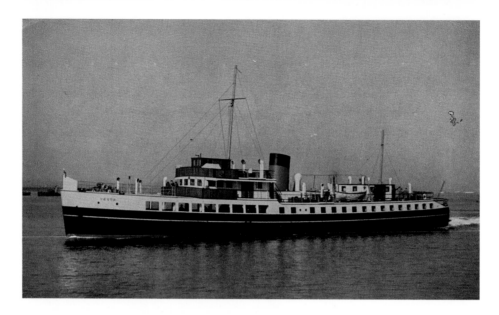

The pleasant-looking *Vecta* of the Red Funnel fleet. She entered service in April 1939 for Red Funnel. She was built by the renowned John Thornycroft yard and provided a year-round passenger and car ferry service between Southampton and Cowes.

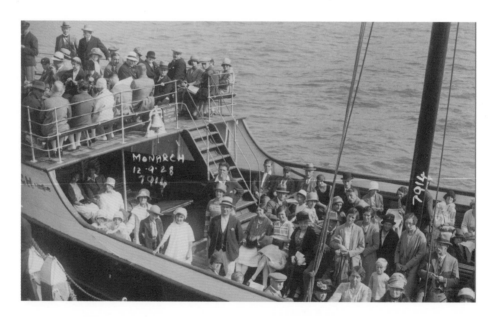

Passengers aboard the *Monarch* in 1928. Paddle steamer trips were incredibly popular at that time. Passengers would crowd the rails while alongside piers to have their photograph taken by a local photographer. They would later collect their print.

Duchess of Cornwall approaching Ryde in 1934. She was originally named *Duchess of York* and took the name *Duchess of Cornwall* in 1928 as a result of her previous name being required for an ocean liner. She wasn't used by the Admiralty during the Second World War, and sunk during a bombing raid at Southampton in 1940. She was recovered and remained in service until being withdrawn in 1946.

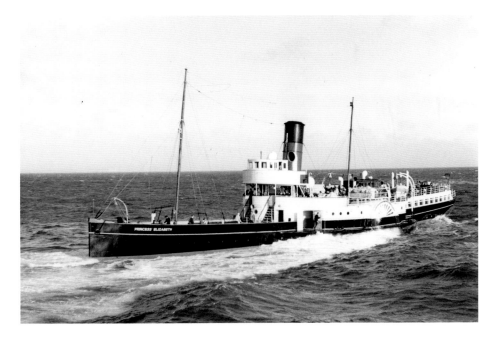

Princess Elizabeth's livery changed a great deal towards the end of her operational career. For the 1965 season *Princess Elizabeth* had a plain black hull. The year before, she had a white line on her hull below the upperworks. Her paddle box had also been picked out in blue instead of red. Her funnel was also a brighter shade of red.

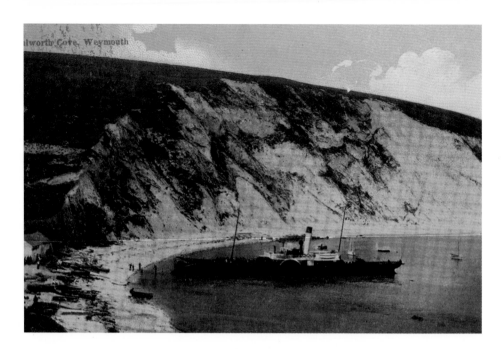

Empress at Lulworth Cove. Cosens' history went back over a century, when Joseph Cosens placed the small paddle steamer *Highland Maid* in service between Weymouth and Portland. She was soon replaced by the larger steamer named *Princess*. The service soon proved to be successful and Captain Cosens developed services and went into partnership with Joseph Drew. They introduced the *Prince* in 1852 and this signalled the expansion of services to places like Poole, Cherbourg and Lulworth Cove.

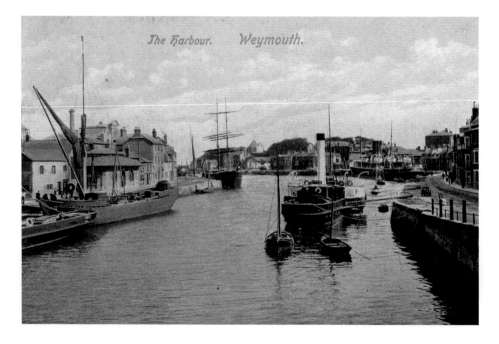

Premier in the harbour at Weymouth.

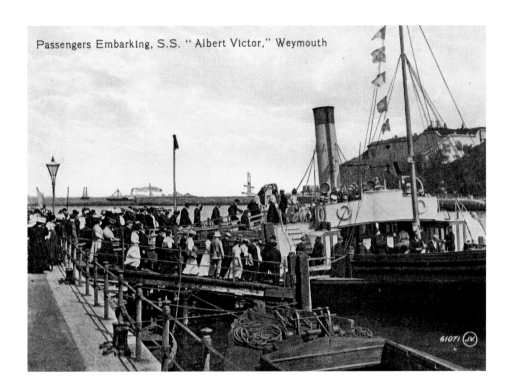

Albert Victor embarking passengers at Weymouth around 1905.

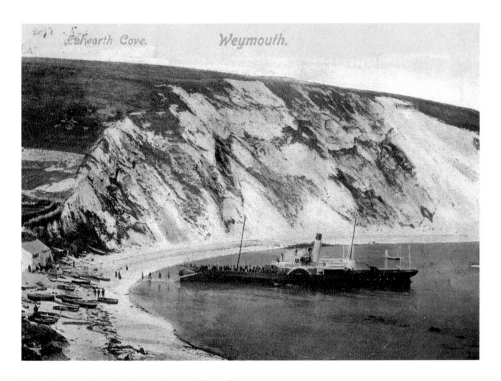

Victoria at Lulworth Cove during Edwardian times.

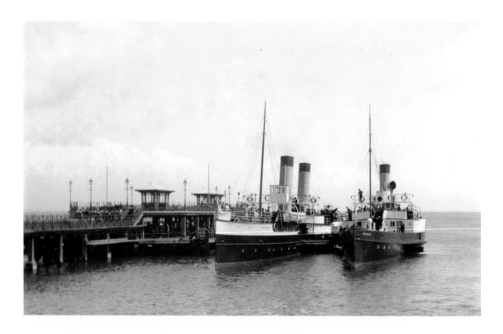

Monarch (left) and *Victoria* (right) at Swanage Pier. The pier was an elegant structure with the ability to disembark and embark large numbers of passengers from the neighbouring resorts of Bournemouth, Weymouth and the Isle of Wight.

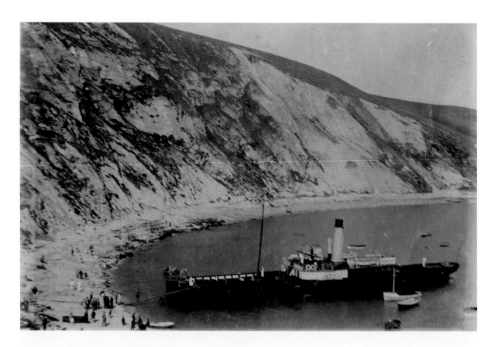

Victoria at Lulworth Cove. With the initial frenzy of demobbed servicemen and civilians wishing to return to their normal peacetime lives, it would seem that the popularity of a paddle steamer trip on a Cosens steamer would flourish forever. *Victoria* and *Empress* once again took up services from Weymouth and soon the piers along the south coast were opened again after work had been undertaken to restore the pier heads.

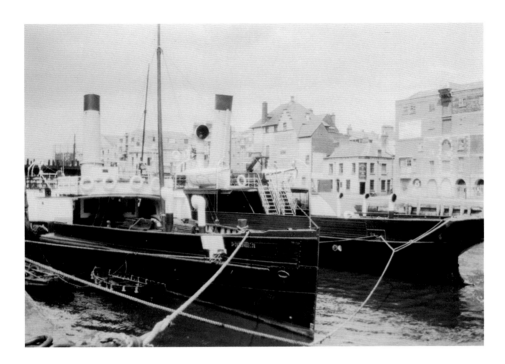

Premier and *Victoria* tied up at Weymouth.

Premier was originally built by the famous Denny yard in 1846 and initially operated on the Clyde. Early in her career she was one of the steamers that escorted Queen Victoria on the royal yacht during her visit to the Clyde. She is shown here some ninety years later on the south coast on 11 July 1936.

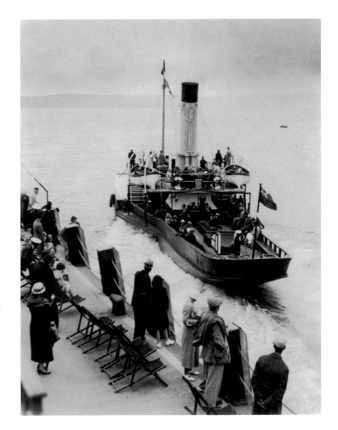

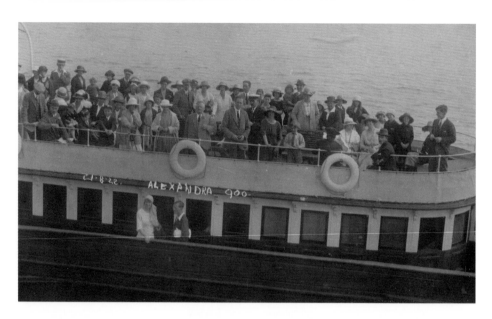

Passengers aboard the *Alexandra* in August 1922. It's always great to look at these souvenir photographs to see how people dressed at the time and to see how they posed. A trip aboard a paddle steamer was a central part of a seaside holiday up to the 1950s. Within less than a generation after this photograph was taken, paddle steamers were in steep decline around the coastline of the UK.

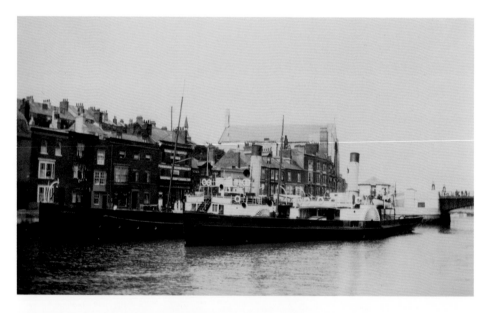

Premier and *Empress* at Weymouth. At the end of the Second World War, Cosens witnessed an era of calm when no new steamers were placed in service, unlike the decades before the First World War. This was a time when motor ships were entering service around the coastline of the UK, but Cosens still preferred traditional-looking and generally modest-sized paddle steamers. Steamers like *Empress* and *Premier* were casualties of the post-war decline when they were seen as old and needing repairs despite being economic in size.

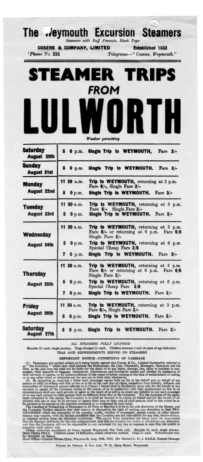

An August 1955 handbill advertising Cosens cruises from Lulworth to Weymouth. By the mid-1950s the Cosens fleet was severely depleted, but it still had three paddle steamers to carry on services and it was hoped that, with a leaner fleet, Cosens would be able to carry out cruising along the Dorset coast for many years to come. *Consul*, *Embassy* and *Monarch* became hugely popular in those final years of the company.

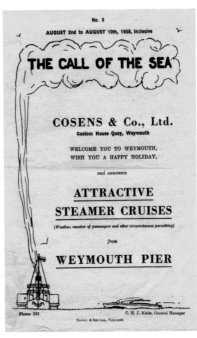

The familiar buff-coloured programme for steamer services by the Cosens of Weymouth fleet. This one dates to August 1958 and lists cruises to Lulworth Cove, Portland Dockyard, Swanage and Bournemouth. Special jazz and pirate cruises were also offered during the week.

The small *Hampton* at Southampton. Small paddle steamers such as this provided a versatile ferrying and tendering role at busy ports such as Southampton. You will notice on the decks several passengers as well as their bicycles.

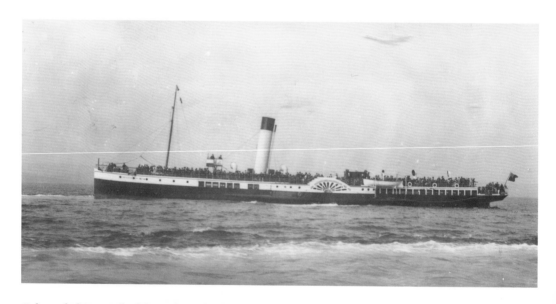

Balmoral photographed from the Waverley in June 1994 when they both took part in the fiftieth anniversary of the D-Day fleet review at Spithead. It was the final appearance of the royal yacht *Britannia* at a fleet review. *Balmoral* is now virtually the only operational survivor of the 1953 coronation fleet review.

THE PIER, COWES, I.W. D.1019.

Emperor of India alongside the pier at Cowes. She saw service in both wars, serving in the eastern Mediterranean as a hospital and transport ship during the First World War and as a flak and training ship during the Second World War.

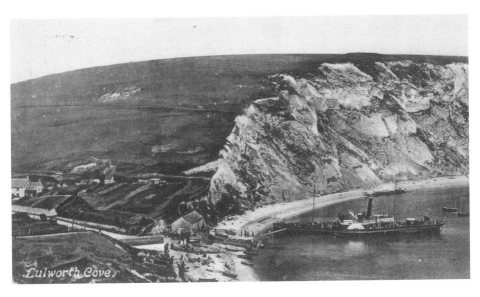

Lulworth Cove is one of the scenic gems of the Dorset coastline. Its closeness to Weymouth made it a natural calling point for the Cosens fleet of Weymouth. During Edwardian times, Cosens were plying further from the resort than ever before and trips to Cherbourg aboard the *Majestic* were popular. Lulworth gained great popularity in the 1950s and 1960s when the Cosens fleet was in sharp decline.

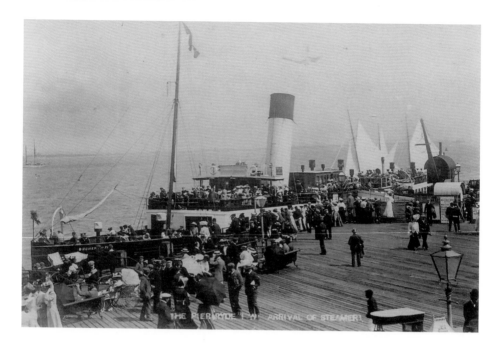

The *Duchess of Fife* at Ryde Pier during Edwardian times. She entered service in 1899 and had a career of thirty years. Note the crane towards the stern of the steamer. This was used to transfer passenger's luggage. The Isle of Wight piers were always busy performing this task as this destination was an island.

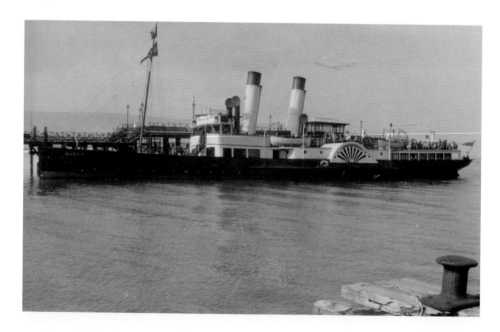

Queen alongside Swanage Pier.

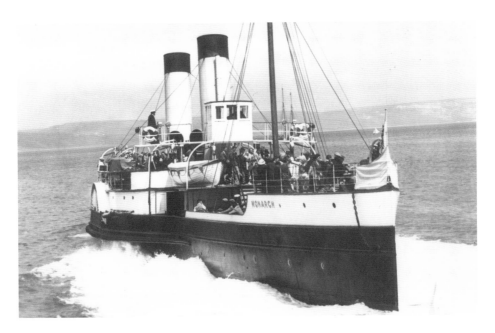

The first *Monarch*. The 1880s saw an increase in competition from a local company that was keen to take some of the trade with their steamer *Lord Elgin*. This inevitably meant that Cosens placed in service larger and better steamers, so *Victoria*, *Monarch*, *Queen* and *Albert Victor* entered service. By the 1870s the founders of the company had died, but the company was strong and was to see significant growth in the decades that followed. By this time the company expanded services and operated to places such as Lyme Regis, Sidmouth and Budleigh Salterton.

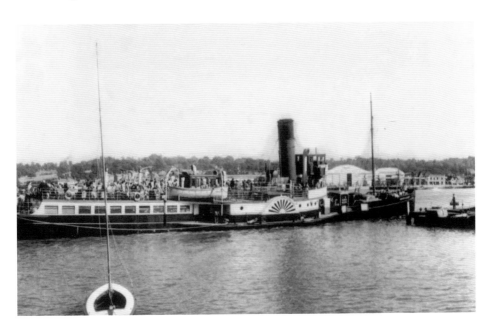

Princess Elizabeth arriving at Cowes during her Red Funnel heyday around the mid-1930s.

Bournemouth Queen was built by Ailsa of Troon in 1908 for Red Funnel. She initially operated the Bournemouth to Swanage service and swiftly became Red Funnel's principal Bournemouth paddle steamer. She served during both world wars and despite her age, was placed in service again in July 1947. She was placed on the Swanage service until she was moved to the Southampton service from the early 1950s until being withdrawn on 29 August 1957. She was scrapped at Ghent in December 1957.

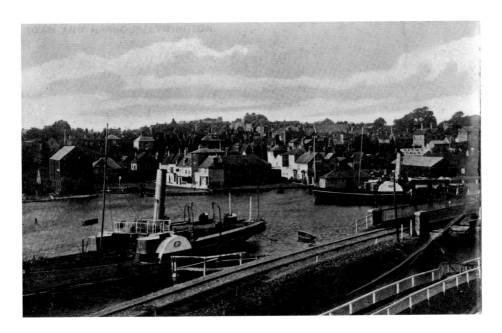

The *Lymington* and *Solent* at Lymington.

An Edwardian view of Lymington and its harbour with a paddle steamer close to the railway line to the harbour.

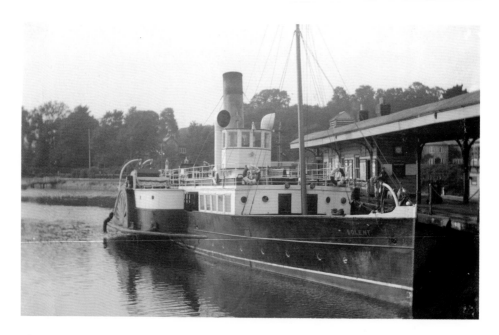

The *Solent* alongside Lymington station pier. Paddle steamers were able to perfect links between the mainland and islands such as the Isle of Wight. They provided a superb service for well over a century until the car ferry became the preferred method of reaching your destination.

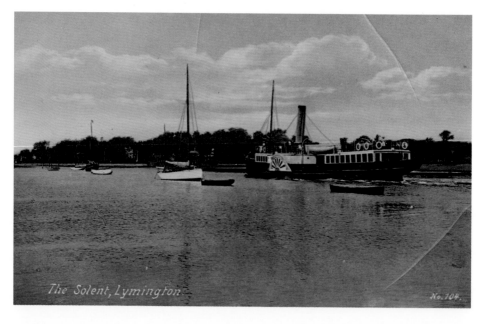

The first paddle steamer services from Lymington to Yarmouth on the Isle of Wight started around 1830. A railway link to the harbour followed in 1858.

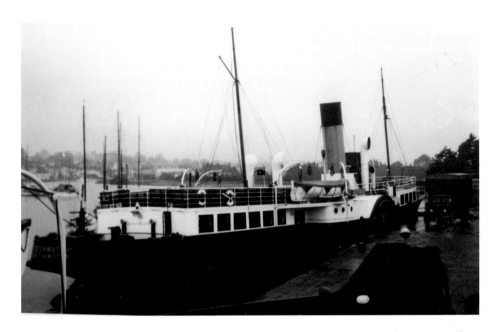

Freshwater at Lymington in August 1958.

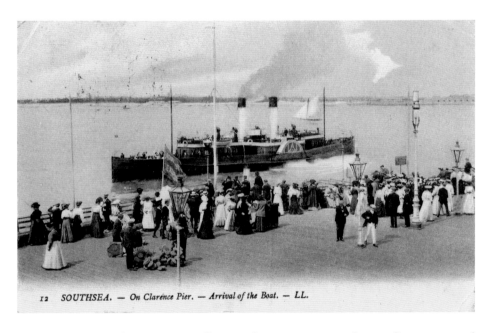

12 SOUTHSEA. — On Clarence Pier. — Arrival of the Boat. — LL.

Clarence Pier at Southsea was originally opened on 1 June 1861. Its fine pavilion was opened by the Prince of Wales in 1882. The pier was enlarged in 1905 to form a large concrete berth to cater for the busy paddle steamer trade.

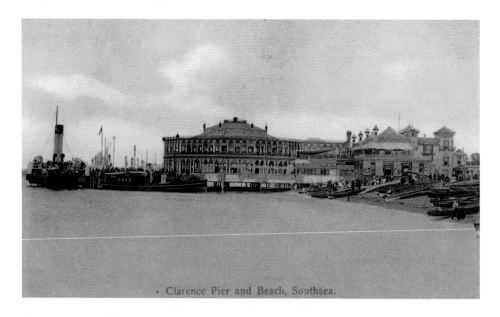

Clarence Pier and Beach, Southsea.

The *Duchess of Albany* at Clarence Pier at Southsea. Clarence Pier's wide deck provided an exuberant array of exciting attractions for paddle steamer passengers. During the Victorian era, piers quickly developed with pavilions and arcades that would entice passengers to part with their very last pennies before they returned home. The heyday of the pleasure pier coincided with the heyday of the paddle steamer.

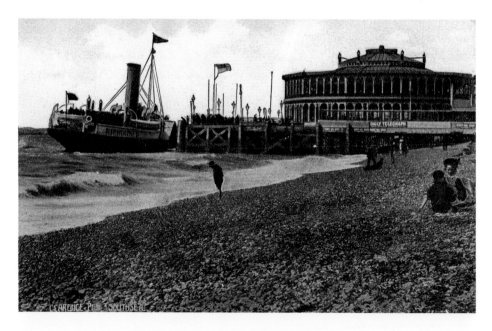

The pier at Southsea with passengers waiting to join the steamer. You can appreciate the vast entertainment pavilion in this view. Important regular ferry services between the mainland and the Isle of Wight were operated along with summer excursion services.

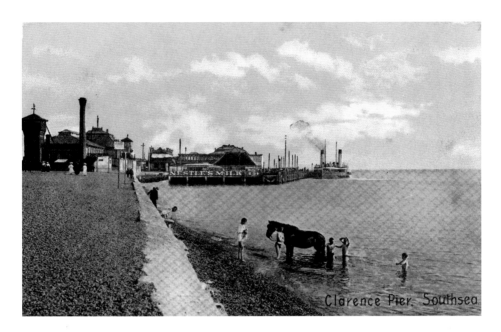

By the 1930s, Clarence Pier was expanded further with the building of kiosks, pavilions and other buildings. It was badly damaged by an air attack during the Second World War and the pier was later rebuilt at the cost of around £250,000. The paddle steamer *Waverley* called at the pier for many years until berthing became unsuitable.

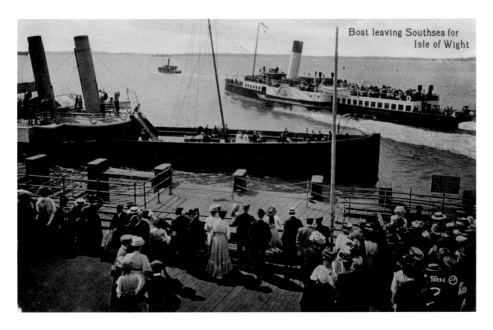

An exciting view at Southsea as paddle steamers arrived and departed during their Edwardian heyday.

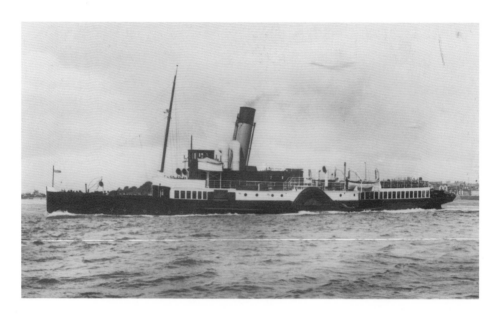

The *Merstone* was built by the Caledon Shipbuilding and Engineering Company in 1928. Along with her sister ship the *Portsdown*, they replaced the steamers *Princess Margaret* and *Duchess of Albany* for the Southern Railway. A notable feature of the *Merstone* was the fact that she had a large and long skylight that gave more than ample light and ventilation to the engine room.

The paddle steamer *Portsdown* operated by the Southern Railway on the Portsmouth to Ryde service.

Southsea was built by Fairfield at Govan and was launched on 2 April 1930. She was built for the Southern Railway for service between Portsmouth and the Isle of Wight. She was 244 feet long and 30 feet wide. She had a relatively short career as she was sunk while undertaking minesweeping duties on 16 February 1941.

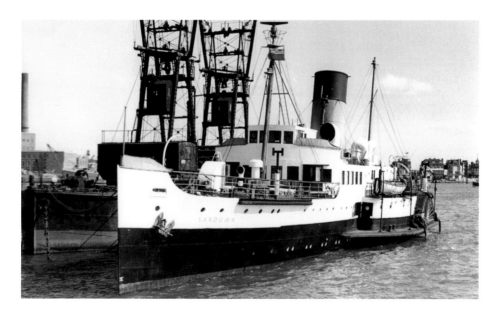

Sandown at Portsmouth during her heyday.

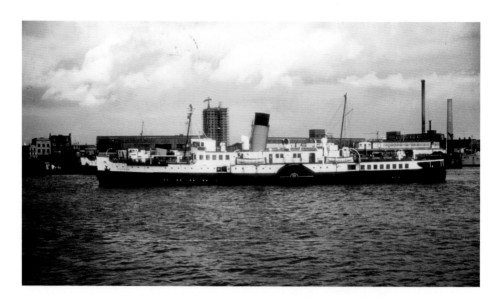

Sandown at Portsmouth. You can see the Southern Railway emblem at the centre of her paddle box. It was announced by British Railways that *Sandown* would be withdrawn on 5 September 1965. On that day she was on Portsmouth and Ryde relief sailings for most of the day but finished by making the very last Ryde to Southsea pier run of the season.

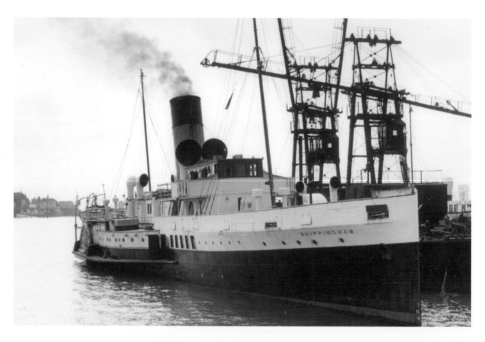

Whippingham had several hull plates renewed and her wheelhouse was repainted white during early 1962. Her 1962 season was shorter than in previous years and she was used on Saturdays undertaking four or five runs from Portsmouth and Ryde. She undertook her last cruises in September. Despite strong rumours, a British Transport Commission spokesman declined to comment on whether she would be withdrawn at that time, but did say that her future was being reviewed.

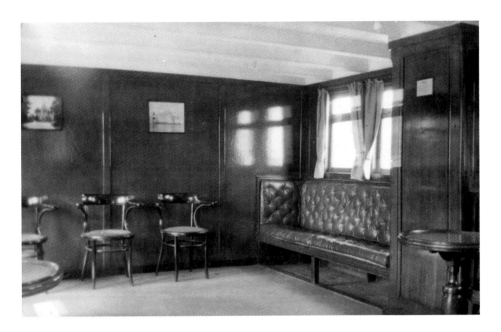

The smoking room of the *Sandown* in 1960. Operators ensured that passenger spaces were comfortable and reflected their company well.

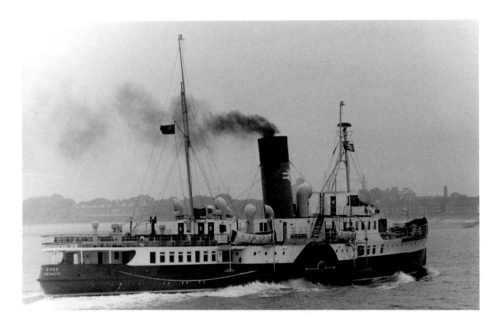

Ryde cruising off Southsea in 1966. Ryde lost the Southern Railway emblem from her paddle box crest after the 1965 season. In 1966 she had an extension fitted to her foremast and main mast, enabling her to comply with new safety regulations.

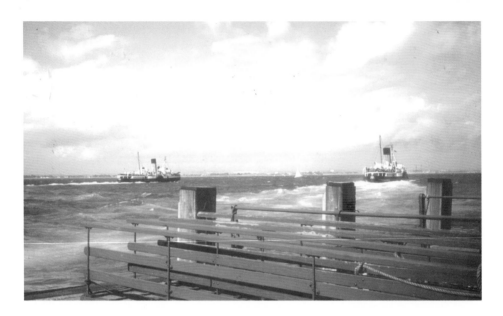

The Southern Railway, and in later years British Railways, provided a superb paddle ferry service between the mainland at Portsmouth and Southsea and the Isle of Wight chiefly at Ryde. Then as now, the only way to reach the island was by boat. Portsmouth had an excellent railway station, but with the mass ownership of the motor car, the type of sea-going vessel had to change and the car ferry took over from the paddle steamers which were withdrawn.

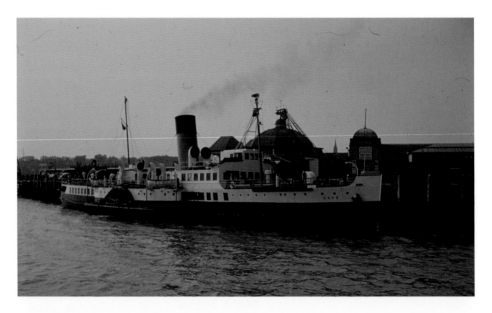

Ryde at Ryde Pier on 7 July 1963. *Ryde* had been built for the Southern Railway by the famed Denny yard at Dumbarton in 1937. Her principal role would be to provide a ferry service between Portsmouth and Ryde on the Isle of Wight with a dual use as a coastal cruising vessel.

Shanklin was one of the well-loved post-war motor vessels that operated the regular ferry service from Portsmouth to the Isle of Wight as well as hugely popular summer excursions. Her life was cut tragically short when she hit rocks at Port Eynon in August 1981 and sank while acting as the consort for Waverley. One wonders what would sort of career she would have had if that sad incident hadn't happened.

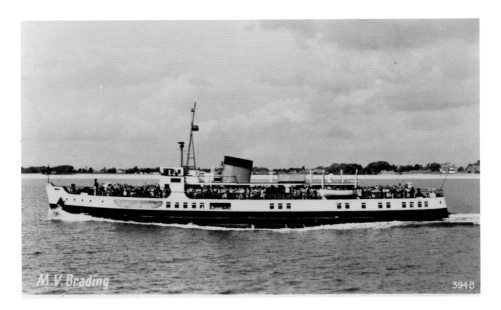

Brading was one of the trio of Denny-built motor ships that provided a superb service in post-war years. You can appreciate her attractive modern look in this view. The trio became well-known for their superb covered and open passenger accommodation that ensured that passengers were given the very best facilities in good or bad weather.

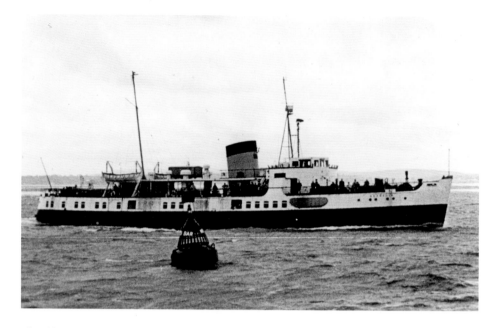

Shanklin entered Portsmouth service in 1951. Her Isle of Wight service didn't last long as by the 1960s services were shrinking due to the rise of the motor car and foreign holidays. She was eventually sold for further service as the consort to the famous *Waverley*. Renamed as *Prince Ivanhoe*, her life was cut tragically cut short when the vessel sank in the Bristol Channel in August 1981.

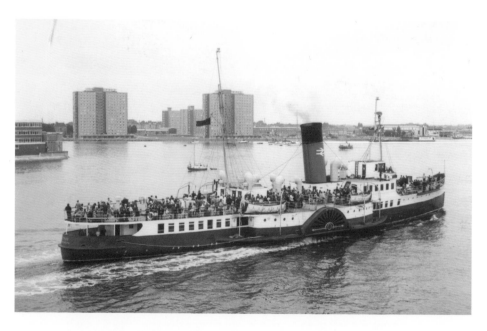

Ryde in her 1960s livery. During the 1966 season, *Ryde* appeared without her Southern Railway emblem on her paddle box. She also had an extension to her foremast to comply with new mast light regulations that year.

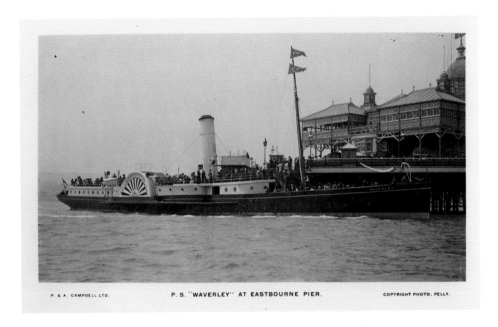

P&A Campbell's *Waverley* at Eastbourne Pier.

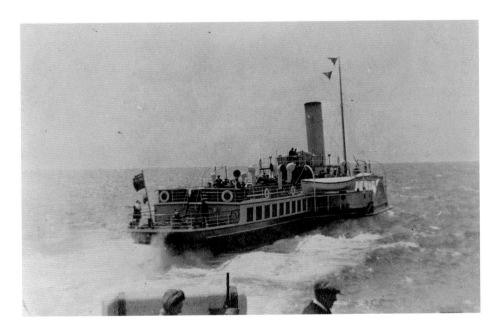

The *Albion* departing from a Sussex pier during her Sussex heyday.

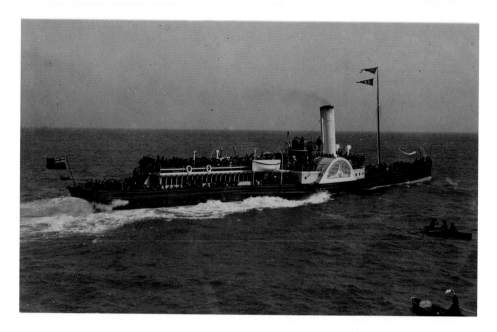

The fine-looking *Boonie Doon* of the P&A Campbell fleet was given the unflattering nickname of 'Breakdown Bonnie' and saw service at Brighton during the Edwardian heyday of the resort. She had been built by the Seath yard at Rutherglen in 1876 and saw service on the Clyde, Thames, Mersey and Bristol Channel. After her Sussex service she returned to the Bristol Channel and was soon after scrapped.

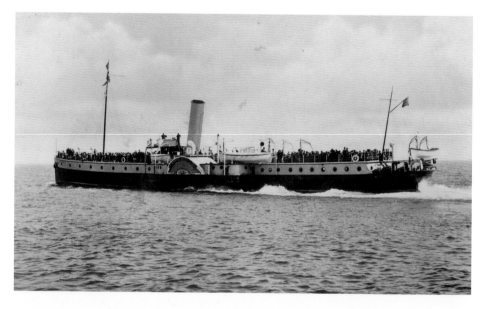

In 1923 *Lady Evelyn* was renamed *Brighton Belle*. In the mid-1930s she was relocated by the company to the Sussex coast, which was, of course, perfectly suited to her new name. *Brighton Belle* became synonymous with Sussex services for those few years before the Second World War disrupted services.

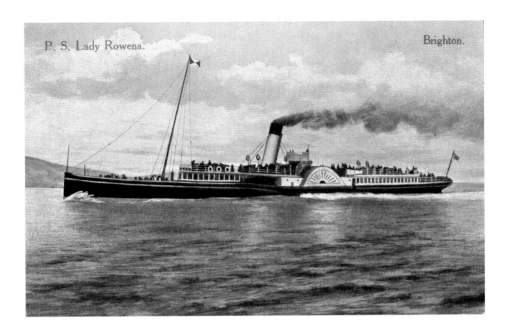

Lady Rowena during south coast service.

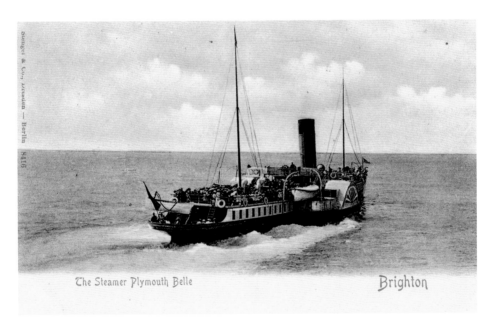

Plymouth Belle departing from Brighton.

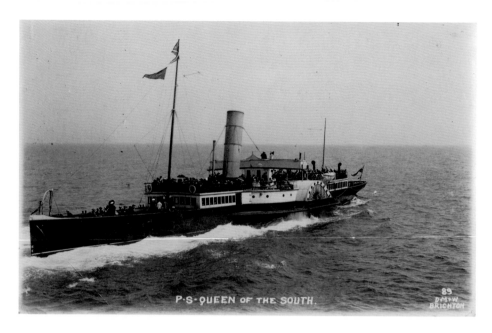

Queen of the South departing from a pier during her south coast heyday.

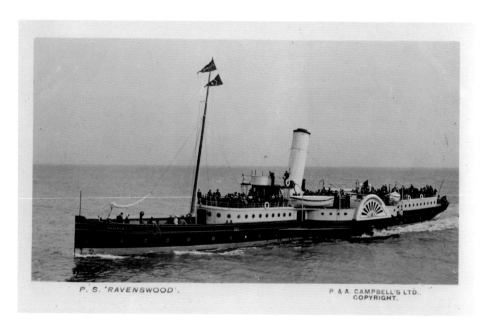

Ravenswood was built by McKnight of Ayr in 1891. The image here shows her after her 1909 refit when her funnel arrangement and bridge was changed. She saw service on the Sussex station from Brighton for three years before the First World War. After wartime service she returned to Sussex as well as undertaking work on the Bristol Channel. She saw service during the Second World War, but by the 1950s she was becoming too old and uneconomic to operate and was then broken up.

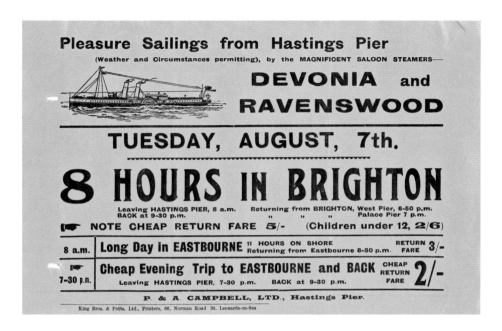

Pleasure Sailings from Hastings Pier

(Weather and Circumstances permitting), by the MAGNIFICENT SALOON STEAMERS—

DEVONIA and RAVENSWOOD

TUESDAY, AUGUST, 7th.

8 HOURS IN BRIGHTON

Leaving HASTINGS PIER, 8 a.m. Returning from BRIGHTON, West Pier, 6-50 p.m.
BACK at 9-30 p.m. „ „ Palace Pier 7 p.m.

☞ NOTE CHEAP RETURN FARE **5/-** (Children under 12, **2/6**)

| 8 a.m. | **Long Day in EASTBOURNE** 11 HOURS ON SHORE Returning from Eastbourne 8-30 p.m. | RETURN FARE **3/-** |
| ☞ 7-30 p.m. | **Cheap Evening Trip to EASTBOURNE and BACK** Leaving HASTINGS PIER, 7-30 p.m. BACK at 9-30 p.m. | CHEAP RETURN FARE **2/-** |

P. & A. CAMPBELL, LTD., Hastings Pier.

King Bros. & Potts, Ltd., Printers, 66, Norman Road St. Leonards-on-Sea

In the days before motor cars the best way to get to your local seaside resort was by paddle steamer. This handbill from 1923 offers trips aboard the *Devonia* and *Ravenswood* from Hastings to Brighton and Eastbourne. It allowed long stays in the resorts. Timetables were constructed to be as economic as possible and evening and half-day trips were slotted into each day's sailings.

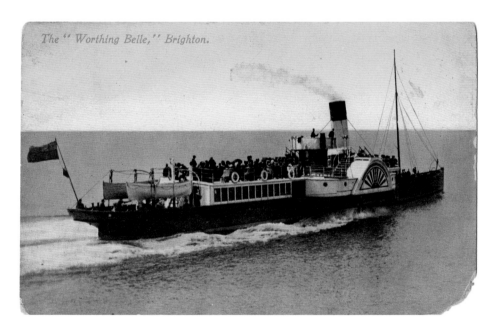

The "Worthing Belle," Brighton.

Worthing Belle departing from the West Pier at Brighton. The pier was designed by the famous Victorian pier designer Eugenius Birch. It was the epitome of British seaside pier design. Sadly, it was closed in the early 1970s and declined in the years that followed.

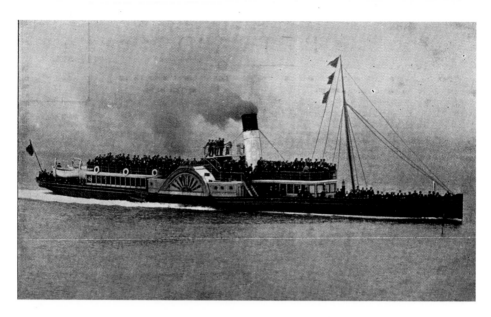

A densely crowded *Worthing Belle* during her Sussex heyday.

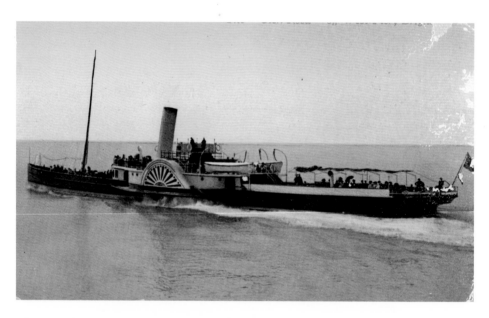

Glen Rosa departing from the West Pier at Brighton. Note the frame and rolled awning at the stern that provided cover for passengers in poor weather. This was a regular feature in the days before paddle steamers had large deckhouses and saloons.

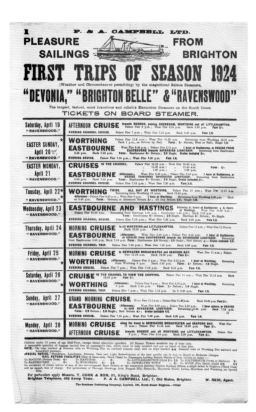

It's hard now to realise how incredibly popular paddle steamer cruises were in the inter-war years. The densely packed handbills of the time show the huge number of cruise options that were available from Brighton, Eastbourne, Hastings and Worthing. A great many cruises would ply between the popular resorts, but others went to France as well as through the Solent to the Isle of Wight and places such as Bournemouth. This handbill dates back to April 1924. A new handbill was issued each week.

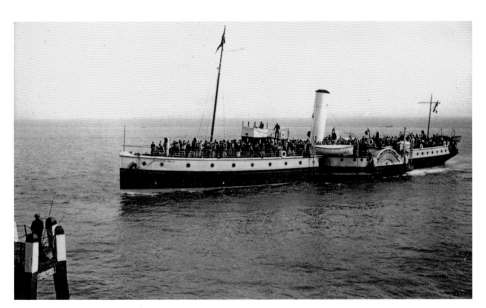

Brighton Belle, like many other paddle steamers, had more than one name during her career. She was originally built for the ambitious Furness Railway and named *Lady Evelyn* after the wife of one of the directors. When the Furness Railway folded, she was acquired for further service by Tuckers in 1919 and later by P&A Campbell in 1922 for the Bristol Channel.

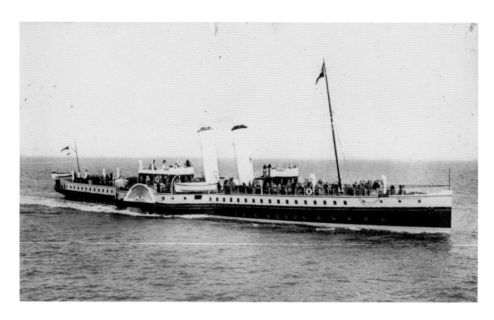

Brighton Queen was one of the most popular paddle steamers of the P&A Campbell fleet.

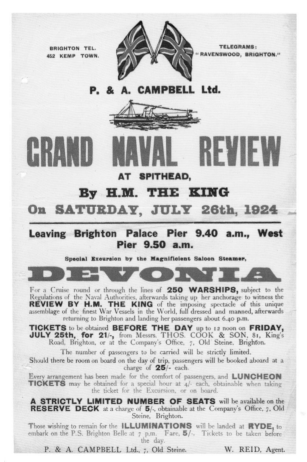

BRIGHTON TEL.
452 KEMP TOWN.

TELEGRAMS:
"RAVENSWOOD, BRIGHTON."

P. & A. CAMPBELL Ltd.

GRAND NAVAL REVIEW

AT SPITHEAD,

By H.M. THE KING

On SATURDAY, JULY 26th, 1924

Leaving Brighton Palace Pier 9.40 a.m., West Pier 9.50 a.m.

Special Excursion by the Magnificient Saloon Steamer,

DEVONIA

For a Cruise round or through the lines of **250 WARSHIPS,** subject to the Regulations of the Naval Authorities, afterwards taking up her anchorage to witness the **REVIEW BY H.M. THE KING** of the imposing spectacle of this unique assemblage of the finest War Vessels in the World, full dressed and manned, afterwards returning to Brighton and landing her passengers about 6.40 p.m.

TICKETS to be obtained **BEFORE THE DAY** up to 12 noon on **FRIDAY, JULY 25th, for 21/-,** from Messrs. THOS. COOK & SON, 81, King's Road, Brighton, or at the Company's Office, 7, Old Steine, Brighton.

The number of passengers to be carried will be strictly limited.

Should there be room on board on the day of trip, passengers will be booked aboard at a charge of **25/-** each.

Every arrangement has been made for the comfort of passengers, and **LUNCHEON TICKETS** may be obtained for a special hour at 4/- each, obtainable when taking the ticket for the Excursion, or on board.

A STRICTLY LIMITED NUMBER OF SEATS will be available on the **RESERVE DECK** at a charge of 5/-, obtainable at the Company's Office, 7, Old Steine.

Those wishing to remain for the **ILLUMINATIONS** will be landed at **RYDE,** to embark on the P.S. Brighton Belle at 7 p.m. Fare, **5/-.** Tickets to be taken before the day.

P. & A. CAMPBELL Ltd., 7, Old Steine. W. REID, Agent.

Naval Reviews at Spithead have always been highly popular events. In July 1924 the *Devonia* offered a cruise to see over 250 warships that were reviewed by George V. The cruise departed from the Palace Pier and West Pier at Brighton and tickets cost £1.25. P&A Campbell were eager to extract as much revenue as possible from passengers and a supplement was charged for those wanting to use the promenade deck or for luncheon.

Devonia at Boulogne around 1931. Trips to France were incredibly popular as passengers could have a novel day ashore in a different country. South coast resorts such as Brighton and Eastbourne provided a perfect embarkation point for the short crossing. *Balmoral* provided the last pleasure steamer trip to Boulogne from Eastbourne on 29 June 1996 with over 200 passengers aboard her.

As well as having large and impressive paddle steamers calling at south coast resorts, there were also large fleets of small beach boats that offered short one-hour cruises from the beach or pier. One of these was the *Countess Betty* that plied from Brighton's West Pier in 1923. They offered a cheap alternative to the more majestic steamers as well as giving the steamer passengers the chance to view the big steamers from the sea.

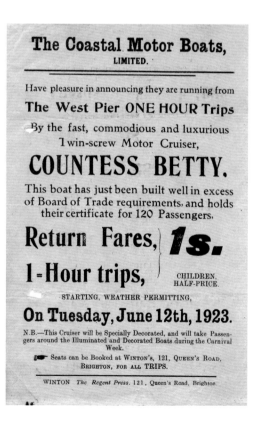

The Coastal Motor Boats,
LIMITED.

Have pleasure in announcing they are running from

The West Pier ONE HOUR Trips

By the fast, commodious and luxurious
Twin-screw Motor Cruiser,

COUNTESS BETTY.

This boat has just been built well in excess of Board of Trade requirements, and holds their certificate for 120 Passengers.

Return Fares, **1s.**

1-Hour trips, CHILDREN, HALF-PRICE.

STARTING, WEATHER PERMITTING,

On Tuesday, June 12th, 1923.

N.B.—This Cruiser will be Specially Decorated, and will take Passengers around the Illuminated and Decorated Boats during the Carnival Week.

☞ Seats can be Booked at WINTON'S, 121, QUEEN'S ROAD, BRIGHTON, FOR ALL TRIPS.

WINTON *The Regent Press*. 121, Queen's Road, Brighton

Cover from P&A Campbell's 1933 English Channel guidebook. The company, like other operators around the UK, published guidebooks for their passengers. These gave details of the steamers in the fleet as well as providing maps for passengers to find out where they were.

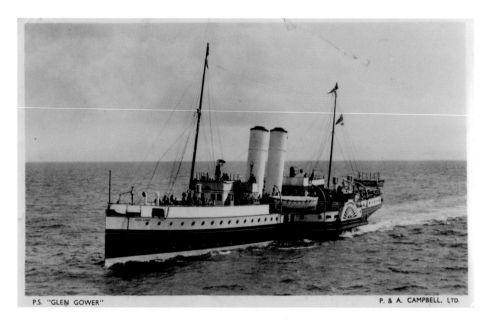

Glen Gower was built by Ailsa of Troon in 1922 and was a popular paddle steamer along the Sussex coast.

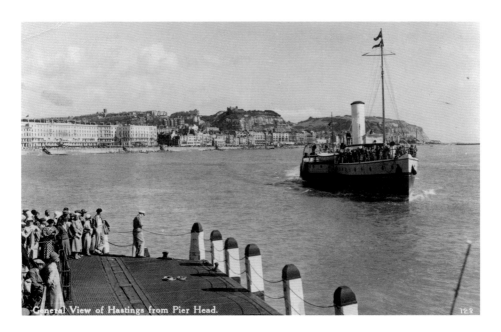

An early 1930s view of a Campbell steamer arriving at Hastings. Hastings Pier welcomed the famous *Waverley* on her first visits to the south coast during the late 1970s.

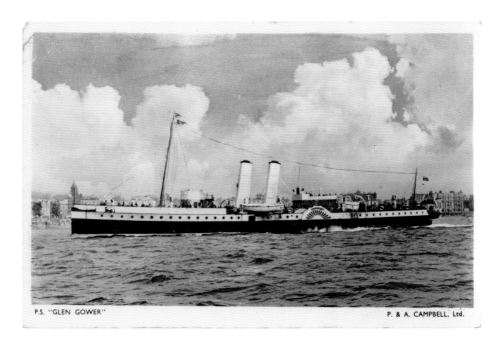

Glen Gower near Brighton. The vessel had a long association with the Sussex resort.

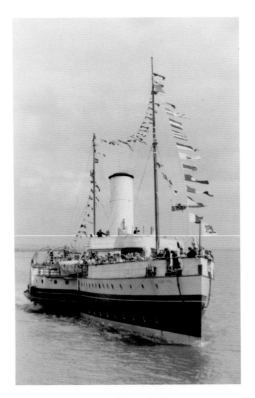

Glen Usk in her heyday. The Campbell fleet ran regular services along the south coast from the late 1890s until the mid-1950s. Brighton, with its two fine piers, was the centre of their Sussex operations.

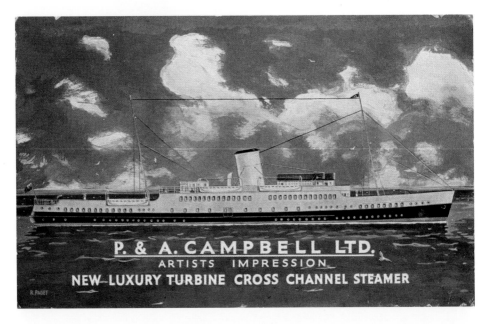

An artist's impression of P&A Campbell's new turbine steamer that was eventually named *Empress Queen*. Campbell always preferred the traditional paddle steamer and many of their Edwardian favourites survived until the 1950s when they were scrapped. The company's last two ships built after the Second World War were the *Cardiff Queen* and *Bristol Queen*.

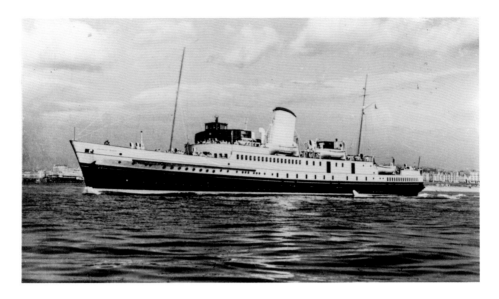

Empress Queen passing Brighton. She was Campbell's only turbine steamer and was built to expand and react to the thirst for cruises to France from south coast resorts. Ordered before the Second World War, she was launched on 29 February 1940 at the Ailsa of Troon yard. After wartime service she took up excursion services from 1947 onwards. She performed this role until 1950, but was found to be too large for the changing needs. Services to France were also somewhat limited until the mid-1950s as pleasure steamers could only undertake coastal cruises and couldn't land passengers at ports. She relocated to Torquay in Devon in 1951 principally to undertake services to the Channel Islands, but, not surprisingly, the new routes proved to be unprofitable. She finally left British waters in 1955 for Greek owners.

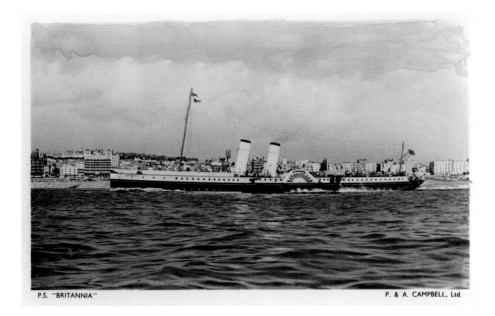

P.S. "BRITANNIA" P. & A. CAMPBELL, Ltd.

The majestic-looking *Britannia* off of the West Pier at Brighton, with the Grand Hotel in the distance.

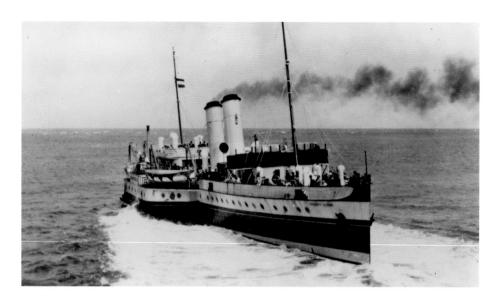

Cardiff Queen was launched in February 1947 and was built by the Fairfield yard. She undertook Sussex coast work, but this was limited due to the contraction of paddle steamer services during the 1950s and early 1960s. She was simply too large for Sussex service and spent her time on the Bristol Channel before she was scrapped in 1968.

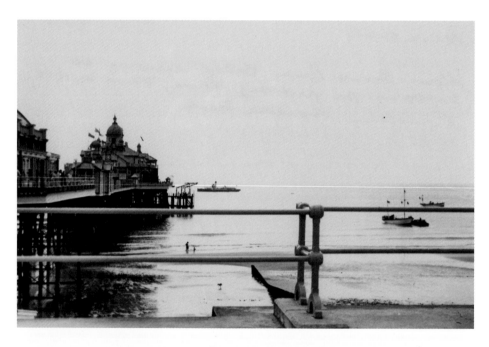

Sussex Queen arriving at Eastbourne Pier for her first trip there on 30 June 1960.

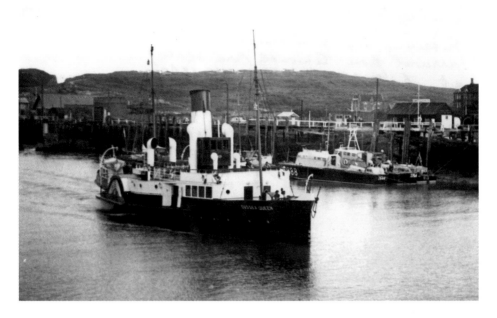

Sussex Queen entering Newhaven harbour on her arrival from Exmouth (via Poole) at 6.15 p.m. on 10 June 1960.

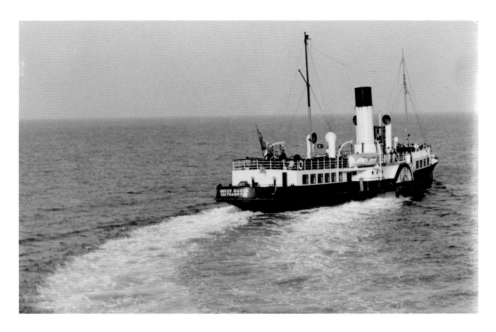

Sussex Queen departing from Eastbourne Pier for Brighton after her last call at Eastbourne on 9 September 1960. She carried a record number of passengers on that day.

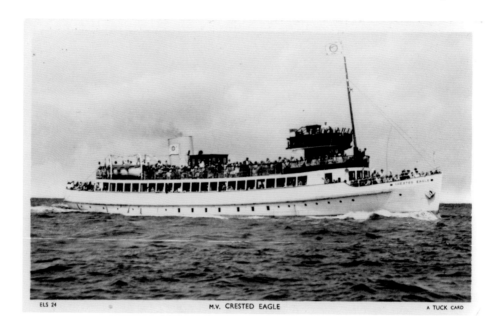

Crested Eagle was originally named *New Royal Lady* for service at Scarborough during the inter-war years. She later took up service with the General Steam Navigation Company on the Thames and was renamed *Crested Eagle*. As services contracted she was chartered to P&A Campbell in 1957 for Sussex services at Hastings and Eastbourne. This venture sadly didn't last for long and she was sold for further service at Malta and was renamed *Imperial Eagle*.

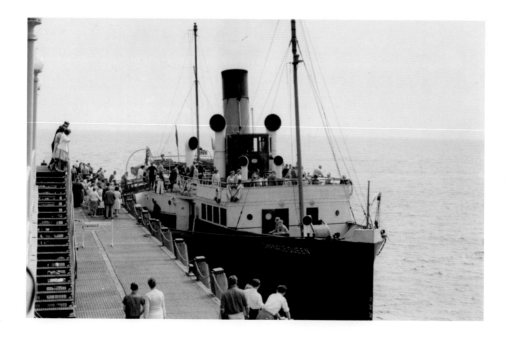

Swanage Queen at Bournemouth. *Swanage Queen* burned around 4.5 tons of coal daily during the early 1960s. This was about half that of the *Monarch*.

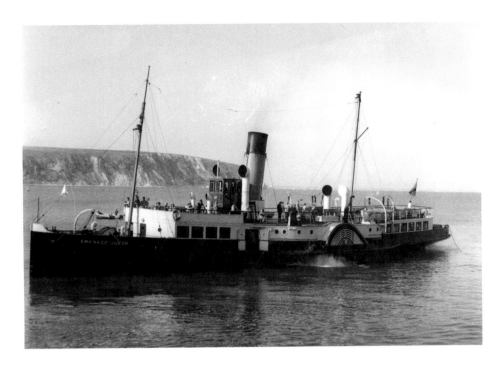

Swanage Queen around 1960.

View of the *Swanage Queen* in 1961.

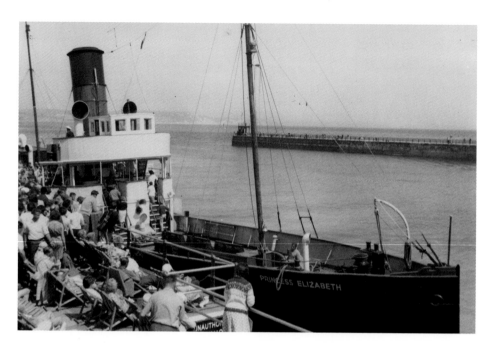

Princess Elizabeth alongside Weymouth Pleasure Pier in 1964. In 1964 *Embassy* returned to Weymouth in April after her survey at Portland. Her 1964 season started on 31 May with a double trip from Bournemouth to Totland Bay on Mondays and Thursday.

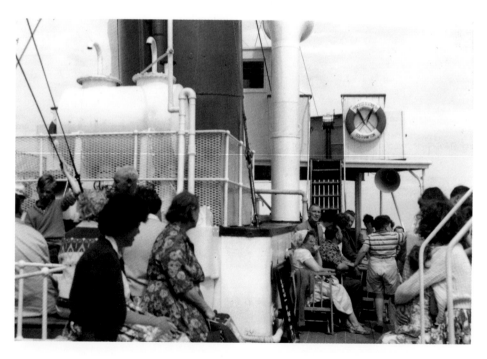

A rare deck shot aboard the somewhat crowded *Princess Elizabeth* during a cruise along the Dorset coastline in 1964.

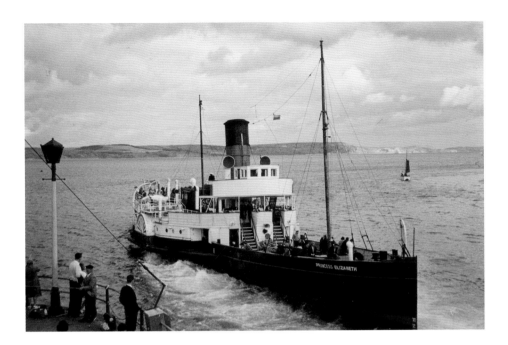

Princess Elizabeth departing from Weymouth on 6 September 1964. In 1964 she went to the Husband shipyard at Marchwood for her pre-season overhaul. She had a red band painted around her hull at this time instead of the white one that she had before.

Princess Elizabeth's final years of operation were full of change as the livery of the steamer, as well as the names of her owners, changed regularly. In 1966 *Princess Elizabeth* had her hull painted white and her funnel cowl was removed. Her wooden deckhouse was also painted white during that year.

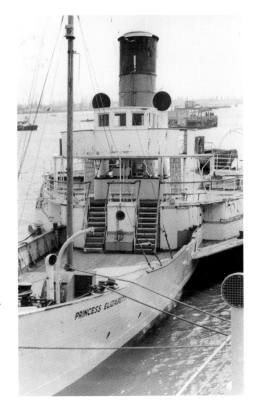

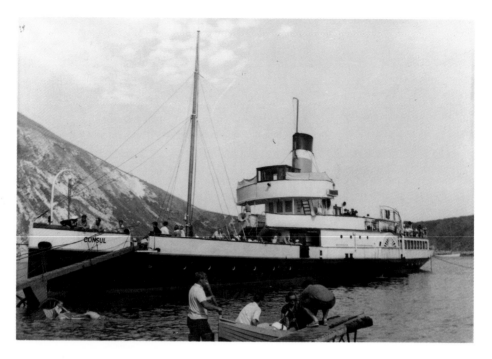

Consul at Lulworth Cove in 1964.

A view aboard the *Consul* in 1964. Sadly, *Consul's* final years of service were often typified by low passenger numbers. Various gimmicks were introduced including games of bingo during cruises.

The stern of the *Consul* at Weymouth in 1964.

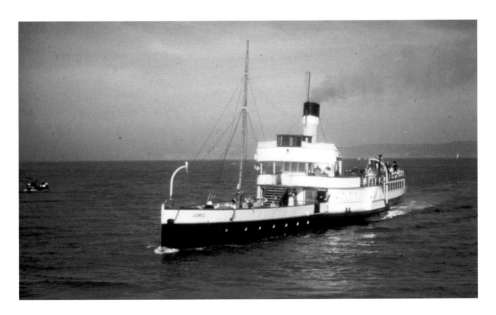

At the end of March 1963 *Consul* was sold to William Smyth who was head of a London-based demolition company that had plans to operate her as an excursion ship, a floating club or casino, or as a floating restaurant. This would take place at Weymouth or on the Thames. Their enthusiasm soon diminished when they realised how much such a project would cost and *Consul* was then sold again.

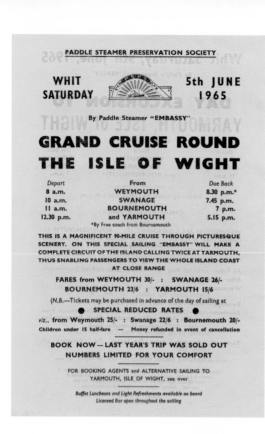

PADDLE STEAMER PRESERVATION SOCIETY

WHIT SATURDAY **5th JUNE 1965**

By Paddle Steamer "EMBASSY"

GRAND CRUISE ROUND THE ISLE OF WIGHT

Depart	From	Due Back
8 a.m.	WEYMOUTH	8.30 p.m.*
10 a.m.	SWANAGE	7.45 p.m.
11 a.m.	BOURNEMOUTH	7 p.m.
12.30 p.m.	and YARMOUTH	5.15 p.m.

*By Free coach from Bournemouth

THIS IS A MAGNIFICENT 90-MILE CRUISE THROUGH PICTURESQUE SCENERY. ON THIS SPECIAL SAILING "EMBASSY" WILL MAKE A COMPLETE CIRCUIT OF THE ISLAND CALLING TWICE AT YARMOUTH, THUS ENABLING PASSENGERS TO VIEW THE WHOLE ISLAND COAST AT CLOSE RANGE

FARES from WEYMOUTH 30/- : SWANAGE 26/-
BOURNEMOUTH 23/6 : YARMOUTH 15/6

(N.B.—Tickets may be purchased in advance of the day of sailing at

● SPECIAL REDUCED RATES ●

viz., from Weymouth 25/- : Swanage 22/6 : Bournemouth 20/-
Children under 15 half-fare — Money refunded in event of cancellation

BOOK NOW—LAST YEAR'S TRIP WAS SOLD OUT
NUMBERS LIMITED FOR YOUR COMFORT

FOR BOOKING AGENTS and ALTERNATIVE SAILING TO
YARMOUTH, ISLE OF WIGHT, see over.

Buffet Luncheons and Light Refreshments available on board
Licensed Bar open throughout the sailing

Handbill advertising a cruise organised by the Paddle Steamer Preservation Society on Whit Saturday 5 June 1965 aboard the *Embassy*. The society did a lot to promote paddle steamer services at the time and to try and keep the tradition alive. Sadly, this had little effect.

Princess Elizabeth alongside Weymouth Pleasure Pier in September 1964. Note the large number of deckchairs stored on the sponson.

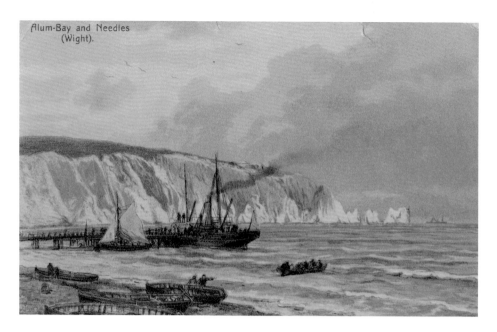

The Isle of Wight provided spectacular scenery for paddle steamers from Sussex, Dorset and Hampshire. The most famous sight for passengers was the famous Needles. Navigation was often a problem in the days before radar and other safety equipment. In 1886 the *Heather Bell* was almost wrecked in dense fog when she rounded the Needles.

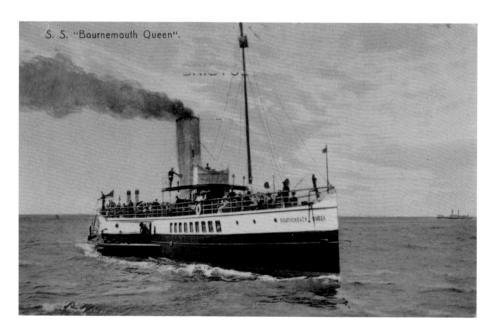

Bournemouth Queen early in her career. She was built in 1908 and became one of the most loved paddle steamers to ever operate along the south coast. She survived until the 1950s when she was scrapped due to her large size and age.

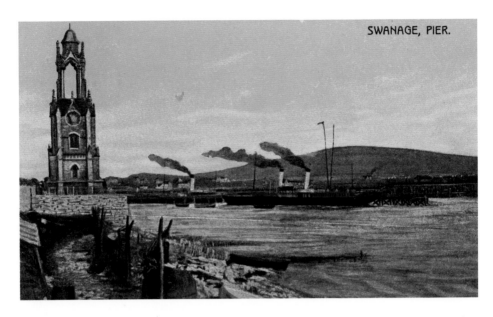

The first Swanage Pier was constructed in 1859–60. By the 1870s it became apparent that the pier wasn't suited to the paddle steamers that plied from it. The new pier was started in 1895 and was completed by 1897. The last paddle steamer to call was the *Embassy* in 1966 and the first was the *Lord Elgin* in 1896.

The paddle steamer *Bembridge*. She operated from Bembridge to Stokes Bay and other local routes.

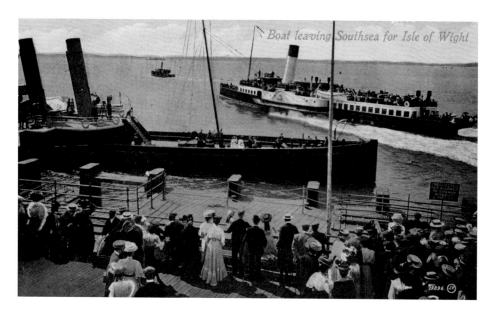

Duchess of Fife departing from Southsea for the Isle of Wight around 1907. She was built on the Clyde in 1899 for the London, Brighton & South Coast Railway. She was principally employed on the ferry service between Portsmouth and the Isle of Wight, but also operated cruises to Bournemouth, Brighton and Swanage.

Queen Victoria's memorable Diamond Jubilee of 1897 inspired a period of growth and change. The event was marked by a large number of paddle steamers from other areas of the UK assembling for the review. The success of the event led to other operators wanting a slice of the revenue on the south coast. With the entry into the arena of P&A Campbell, Cosens and Red Funnel needed to react.

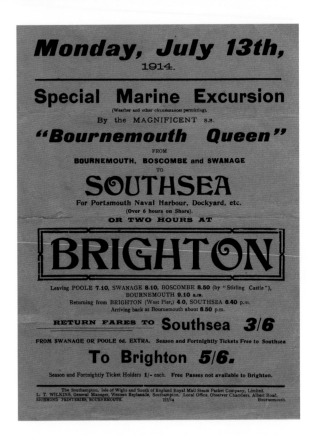

Monday, July 13th,
1914.

Special Marine Excursion
(Weather and other circumstances permitting).

By the MAGNIFICENT s.s.

"Bournemouth Queen"
FROM
BOURNEMOUTH, BOSCOMBE and SWANAGE
TO

SOUTHSEA
For Portsmouth Naval Harbour, Dockyard, etc.
(Over 6 hours on Shore).
OR TWO HOURS AT

BRIGHTON

Leaving POOLE 7.10, SWANAGE 8.10, BOSCOMBE 8.50 (by "Stirling Castle"),
BOURNEMOUTH 9.10 a.m.
Returning from BRIGHTON (West Pier), 4.0, SOUTHSEA 6.40 p.m.
Arriving back at Bournemouth about 8.50 p.m.

RETURN FARES TO Southsea 3/6

FROM SWANAGE OR POOLE 6d. EXTRA. Season and Fortnightly Tickets Free to Southsea

To Brighton 5/6.

Season and Fortnightly Ticket Holders 1/- each. Free Passes not available to Brighton.

The Southampton, Isle of Wight and South of England Royal Mail Steam Packet Company, Limited.
L. T. WILKINS, General Manager, Western Esplanade, Southampton. Local Office, Observer Chambers, Albert Road,
RICHMOND PRINTERIES, BOURNEMOUTH. 7/7/14 Bournemouth.

The south coast offered enormous potential for paddle steamer services. Queen Victoria's Diamond Jubilee in 1897 created a huge appetite for steamer trips and the massive paddle steamers enabled services to operate over larger areas. This Red Funnel handbill from 1914 shows that splendid cruises were then possible from Bournemouth, Swanage and Southsea to the vibrant Sussex resort of Brighton where passengers could enjoy two hours ashore before returning home.

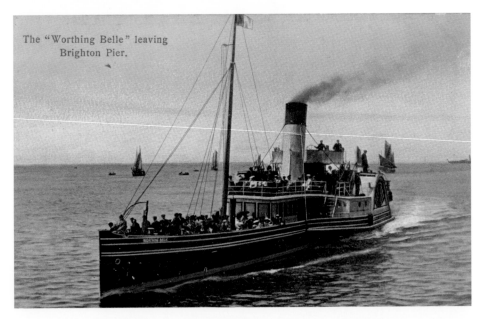

The "Worthing Belle" leaving Brighton Pier.

Worthing Belle departing from Brighton during Edwardian times. Sussex resorts such as Brighton never became synonymous with pleasure steamers as other resorts, such as Bournemouth, Swanage and Weymouth, did.

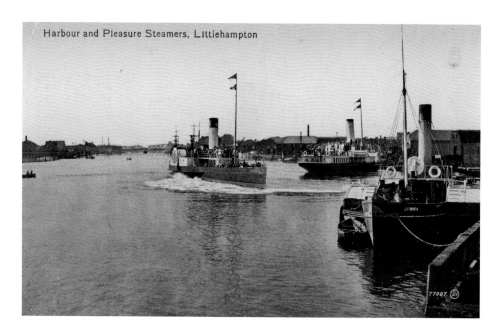

Worthing Belle and *Albion* at Littlehampton. *Worthing Belle* was built by Barclay Curle & Co. in 1885 and was originally named *Diana Vernon*. She was renamed as *Worthing Belle* for Brighton service in 1901 and continued in that role until 1913 before being sold. *Albion* was built at Clydebank in 1893. She was purchased by P&A Campbell in 1899 and then saw service along the Sussex coast. She saw service during the First World War, but was unfit for further service after the conflict so was scrapped. Her engine though was reused in the *Glen Gower*.

Handbill advertising pleasure sailings from Hastings Pier on 1 August 1923. On that day *Ravenswood* and *Devonia* offered classic cruises along the coast as well as a cruise to Boulogne with two hours ashore. Charabanc tours to the First World War battlefields became popular in the years after the war.

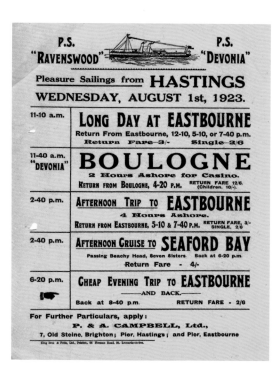

69

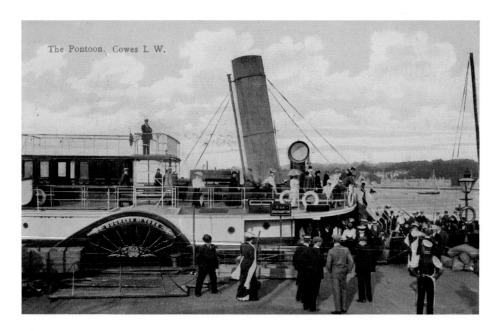

The Pontoon. Cowes I. W.

Red Funnel's *Duchess of York* alongside Cowes Pier around 1905. Red Funnel has remained the most important ferry company on the south coast since Victorian times. Their services have primarily operated between their home port of Southampton and Cowes on the Isle of Wight. They have operated to other destinations, particularly during busy summer months of pleasure cruises.

Lord Elgin was built in 1876 by Richardson, Duck & Co. of Stockton-on-Tees. Initially based in Scotland, she moved south to Bournemouth in 1881.

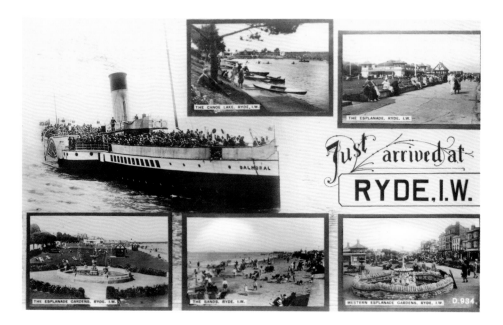

The paddle steamer *Balmoral* arriving at Ryde. *Balmoral* was built by the McKnight yard of Ayr and was launched on 15 May 1900. She became a popular steamer of the Red Funnel fleet and served in both world wars as a minesweeper and anti-aircraft vessel. She was broken up at Northam in 1949.

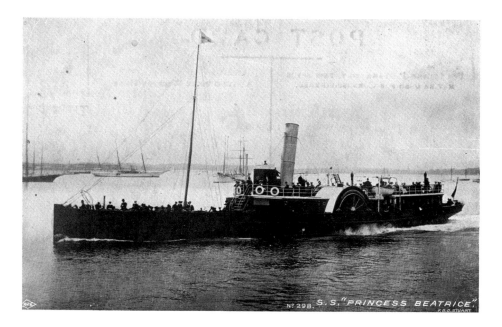

The small paddle steamer *Princess Beatrice* was built by Barclay Curle & Co. of Glasgow in 1880 for Red Funnel. She spent her career on the Southampton to Cowes ferry service. She was withdrawn in 1930 and scrapped three years later.

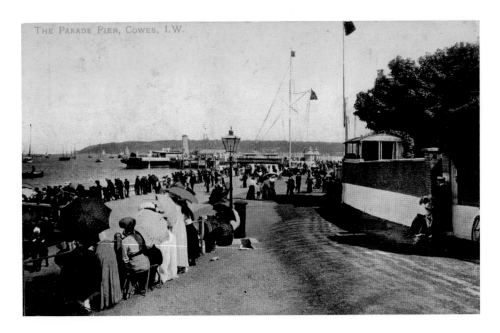

Cowes has always been a busy place to watch boats and ships such as paddle steamers arriving from Southampton and elsewhere. It was the most important Isle of Wight route operated by the company and was, of course, closely situated to Queen Victoria's house at Osborne.

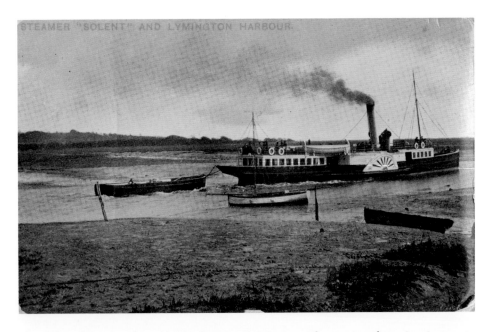

The *Solent* departing from the harbour at Lymington. There were three Lymington to Yarmouth paddle steamers that bore the name.

THE CLIFF PATH, SANDOWN, I.W. 672

Southsea alongside Sandown Pier on the Isle of Wight around 1933.

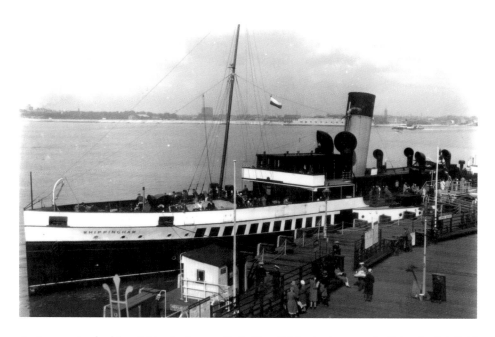

An impressive-looking *Whippingham* at Ryde Pier. *Whippingham* was built by the Fairfield yard in 1930 for the Southern Railway. She was launched at the same time as the *Southsea* and both steamers were around twice the size of their predecessors, showing the huge demand for services during the late 1920s and early 1930s.

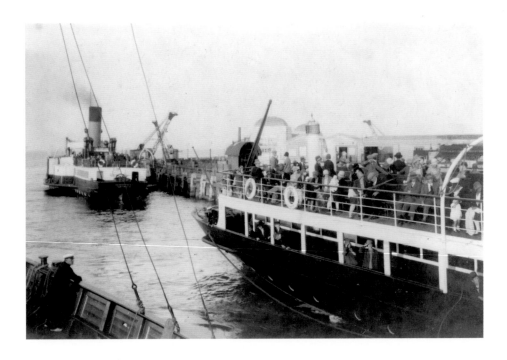

A busy time as paddle steamers move in a harbour. Paddle steamers were low draft and so were very suitable for moving in harbours.

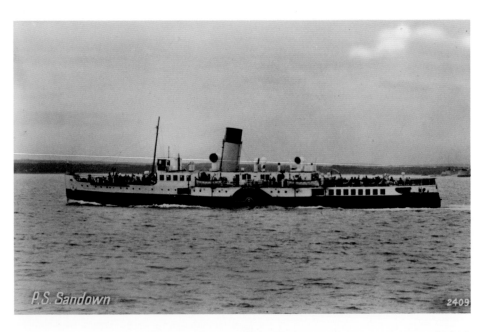

Sandown was the sister paddle steamer of the *Ryde*. She had an impressive promenade deck with ample saloons and a dining saloon on her lower deck.

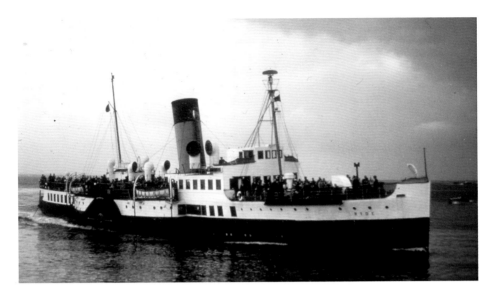

Ryde carried on in the 1950s as she had done in pre-war days. By the late 1940s things were changing and both her livery and fortune were changed when the nationalised British Railways took over from the Southern Railway. Very soon the new body implemented a modernisation programme and paddle steamers, such as the *Ryde*, saw revolutionary new motor vessels from the Denny yard become a threat.

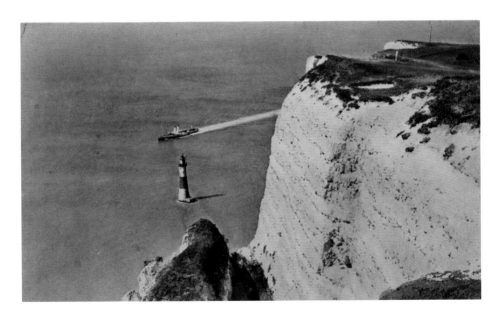

A Campbell paddle steamer passing the beautiful scenery of Beachy Head with its lighthouse. The Sussex coastline is dramatic in places and is dotted with many developed popular seaside resorts such as Brighton, Eastbourne and Hastings. Paddle steamer cruises more or less ceased in the mid-1950s, but were taken up again with *Balmoral* and *Waverley* some twenty-five years later. Sadly, the landing stages at the famous piers have become derelict and cruises are now very rare.

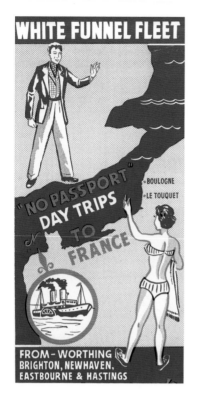

Brochure advertising 'No Passport' day trips to France by P&A Campbell from Sussex in 1955. Such days out were immensely popular from Sussex in post-war years. In 1955 it cost £1.92 for a day trip to France from Brighton. Passengers had around three hours ashore in Boulogne.

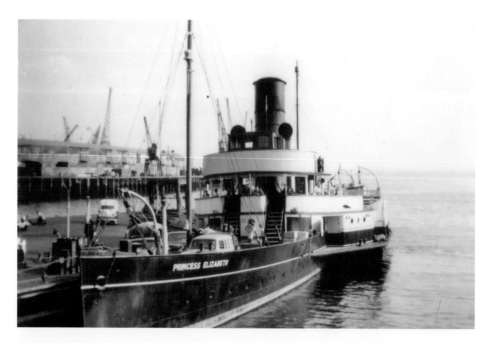

Princess Elizabeth towards the end of her career. Her owners, Red Funnel, realised that the car would inevitably become more important in the future and introduced purpose-built car ferries earlier than its competitors. Paddle steamers such as the *Princess Elizabeth* soldiered on, but their days were numbered by the 1950s.

Freshwater was built by J. Samuel White & Co. of Cowes in 1927 to replace the steamer *Lymington*. She was the maximum size that could use the river at Lymington at low water.

The last Portsmouth railway steamers were immensely popular during the final decades of the paddle steamer. Forty years earlier the fleet had increased dramatically as demand for services was at its peak. Steamers such as the *Whippingham* and *Southsea* could carry around 600 first-class and 467 second-class passengers during the 1930s. By the 1960s demand had shrunk dramatically.

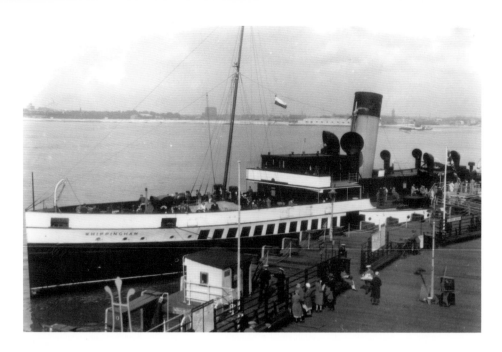

Whippingham during her pre-war heyday. *Whippingham* was advertised for sale on 4 December 1962. Despite rumours that she had been purchased for Sussex coast service, she was sold to Belgium-based breakers, departing Portsmouth on 17 May 1963 for Ghent, being towed by the tug *Bulldog II*.

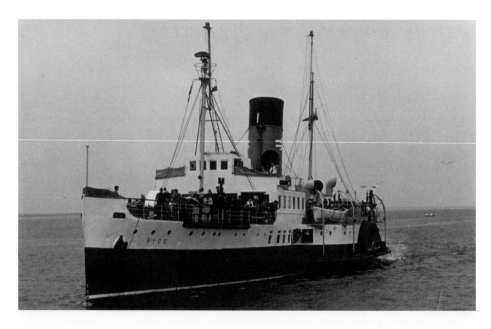

Ryde in June 1969. In 1963 a survey was undertaken at Portsmouth as to whether the then elderly paddle steamers should be withdrawn in favour of modern motor vessels. By that time *Whippingham* had already undergone a heavy overhaul in June 1962 and further heavy repairs were required.

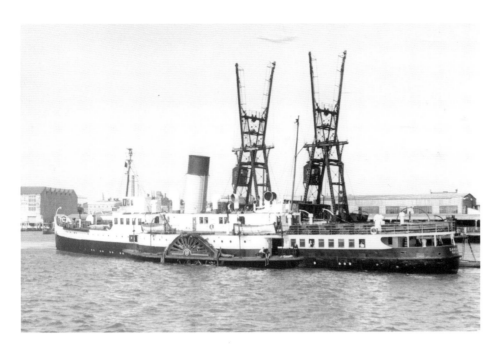

Sandown ready to undertake more ferry services between Portsmouth and the Isle of Wight.

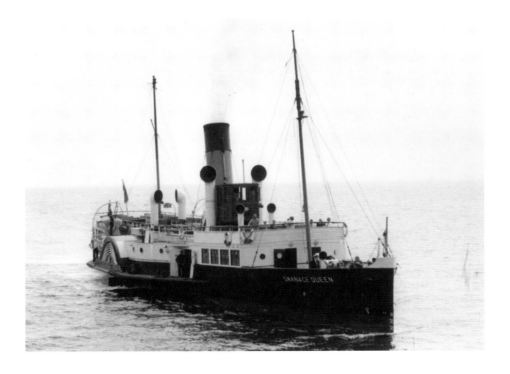

Swanage Queen during her short south coast career in the early 1960s.

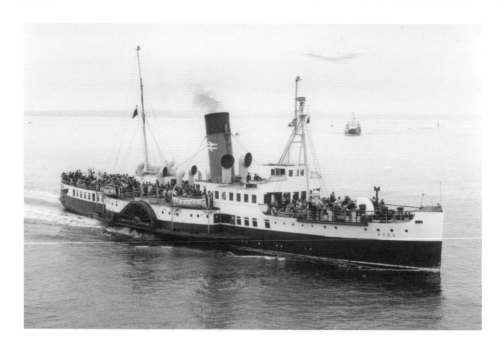

Ryde toward the end of her career. *Ryde*, like many other south coast pleasure steamers of her era, has evaded the scrapyard, but has ultimately faced an uncertain future.

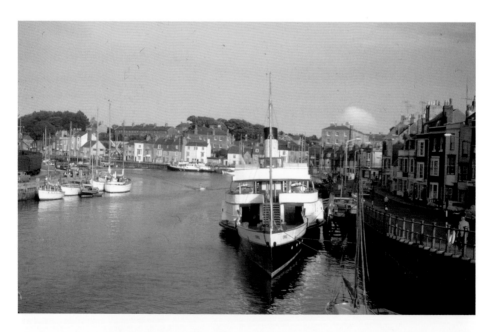

Consul at Weymouth in August 1962. Cosens announced at the end of January 1963 that the *Consul* would be withdrawn from service. She had been losing money for two years. Meetings were held and support was demanded to retain *Consul* at the resort and to find a future use for her.

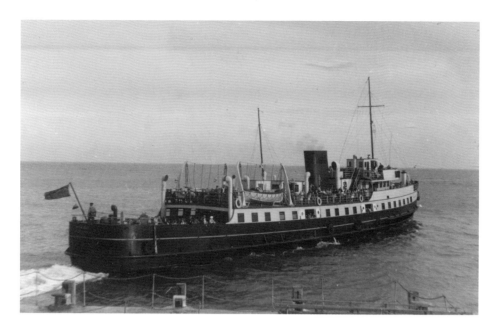

Balmoral departing from Shanklin on 13 August 1952 showing the open car deck at the stern.

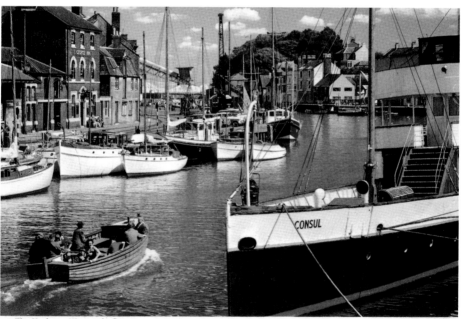

The Harbour, Weymouth, Dorset.

Photo : E. Nägele, John Hinde Studios.

Consul in the charming harbour at Weymouth at the end of her career at the famous Dorset resort. She had been a regular feature at Weymouth for several decades and was a great favourite with passengers in post-war years offering popular trips to Lulworth Cove.

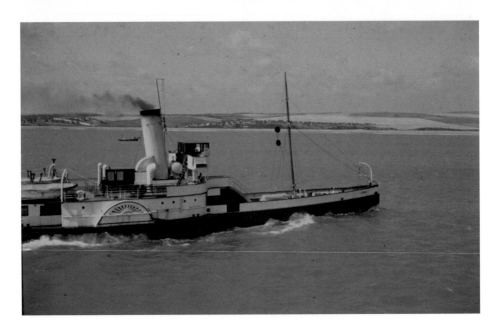

Consul arriving at Newhaven on 18 August 1963. *Consul*'s season at Sussex and on the Thames wasn't a success, but paved the way for preservation efforts in the decade that followed. Sadly, the steamers that were used to reinvigorate services were either too slow or too old and inevitably they failed.

Britain's most famous paddle steamer the

"CONSUL"

operates Regular Cruises from

EASTBOURNE

as under

"CONSUL" is the oldest paddle steamer in the country. She has all the attractions of these ships—gleaming engine room machinery and the seaside atmosphere, plus spacious decks and comfortable bars and lounges.

No. 1. **12th JULY to 26th JULY**

SUNDAYS

Depart 10.30 a.m. Cruise towards SEAFORD viewing the lovely Sussex coastline. Back 12.30 p.m. Fares: 7/6; Children 2/6d.
Depart 2.30 p.m. Cruise round ROYAL SOVEREIGN LIGHTSHIP. Back at 4 p.m. Fares: 7/6.; Children 2/6d.
Depart 4.15 p.m. Cruise towards SEAFORD BAY. Back at 6.15 p.m. Fares: 7/6d.; Children 2/6d.
Depart 6.30 p.m. Evening Cruise to NEWHAVEN (Single trip only). Arrive 8 p.m. Fares: 3/6d.; Children 2/6d.
Passengers may return by 'bus or train. There are frequent services between Newhaven and Eastbourne.

MONDAYS and WEDNESDAYS

Depart 10.30 a.m. for HASTINGS. Arrive 12 noon, allowing 4½ hours ashore. Back 6 p.m. Fares: 8/6; Children 2/6d.
Depart 6.30 p.m. Evening Cruise to NEWHAVEN (Single trip only). Arrive 8 p.m. Fares: 3/6d.; Children 2/6d.

FRIDAYS

Depart 10.30 a.m. Round trip to HASTINGS. Have lunch in Consul's up-to-date comfortable Dining Saloon. Back at 1.30 p.m. Fares: 8/6d.; Children 2/6d.
Depart 2.30 p.m. Cruise round ROYAL SOVEREIGN LIGHTSHIP. Back at 4 p.m. Fares: 7/6d.; Children 2/6d.
Depart 4.15 p.m. for HASTINGS (not landing). Back 7 p.m. Fares: 8/6d.; Children 2/6d.
Depart 7.15 p.m. for NEWHAVEN (Single trip only). Arrive 8.45 p.m. Fares: 3/6d.; Children 2/6d.

All Sailings liable to alteration. being subject to weather, tides and/ or other conditions outside the control of the Company.

South Coast and Continental Steamers Ltd., West Quay, Newhaven

Handbill for cruises from Eastbourne by the *Consul* in July 1963. Southern & Continental Steamers was formed in April 1963 by Tony McGinnity and Eileen Pritchard along with two Bournemouth businessmen to operate the *Consul* which had been purchased from William Smyth. Painting and other work took place aboard her in May and she departed for Poole in Whitsun for slipping. She was to be operated by Captain De Frates in her new role. Captain De Frates had been master of the *Princess Elizabeth* as well as the *Consul* for Cosens of Weymouth.

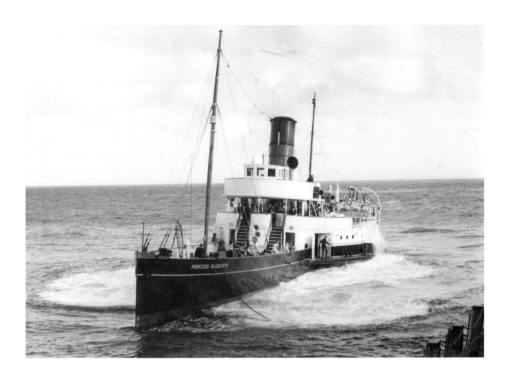

Princess Elizabeth arriving at a south coast pier. In 1962 *Princess Elizabeth* operated four sailings from Bournemouth and five sailings from Swanage on Mondays to Fridays. Her off service day was on Saturday. Her fares were between six and seven shillings, which was cheaper than Cosens and Croson. Despite this, *Princess Elizabeth* didn't do well, mainly because of the better timings of the Croson fleet from Bournemouth.

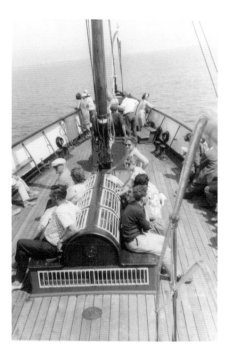

A view of *Consul* in 1964 that gives a wonderful view of the reasons why she was so charming and popular. Passengers were able to have the invigorating pleasure of standing right at the bow. What better way to experience a paddle steamer? Sadly, the motor car soon took over and passengers were then only able to sit in traffic jams on busy roads at bank holidays.

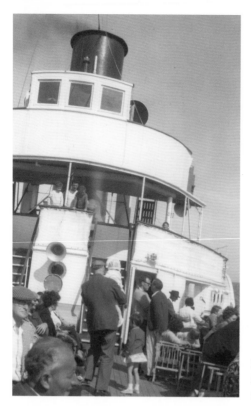

Passengers crowd the deck of the *Princess Elizabeth* in 1964 while on a Dorset coastal cruise.

Princess Elizabeth at Weymouth on 6 September 1964. At Whitsun 1964, *Princess Elizabeth* operated cruises from Weymouth and she continued these between 31 May and 26 June apart from a few cruises to Yarmouth. *Consul* operated in opposition to her during that season.

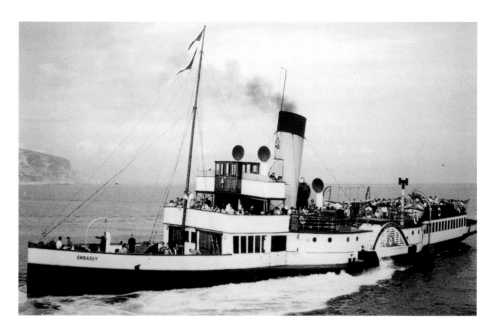

Embassy departing from Swanage. Cosens' role as operators of paddle steamers came to an end in May 1967 when their last steamer, *Embassy*, was sold to Belgian shipbreakers at Boom. Before her final journey her windows were boarded up and she was moved to the outer harbour during the middle of the month. Poor weather delayed her departure, but she finally left under tow from the tug *Fairplay II* on 25 May. She arrived at the Antwerp shipbreaking yard two days later.

After the paddle steamers departed, places such as Bournemouth were left without any large ship. Luckily, services continued with vessels such as the *Bournemouth Belle*. Continued usage of piers has ensured that landing facilities have been kept for vessels such as *Waverley* and *Balmoral* that have visited the south coast since the late 1970s.

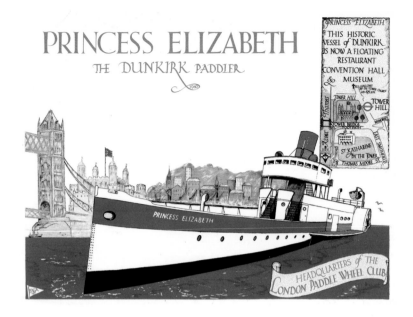

PRINCESS ELIZABETH
THE DUNKIRK PADDLER

The Red Funnel fleet has produced several steamers that have had long preservation careers. *Balmoral* has operated as consort to *Waverley* since 1986 and *Princess Elizabeth* has also survived despite several dramas. After several attempts at operating her, she has found a solid role as a static vessel. She spent a long time at London as a floating bar. Since the late 1980s she has been located at Dunkirk in a similar role.

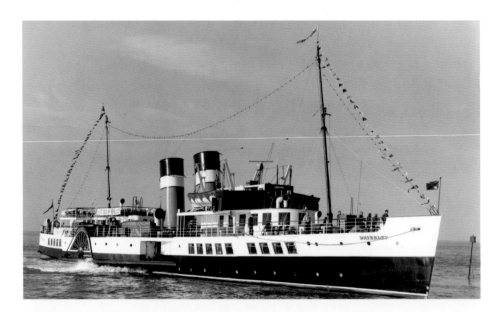

Waverley entered her preservation career in 1975. It soon became apparent that the short Clyde season wouldn't be enough to enable her to have a stable future. In 1977 she was invited to the centenary celebrations of Llandudno Pier. This provided the catalyst that saw her travel further afield from the Clyde. The south coast was one of the first places that she visited and *Waverley* has returned every year since that time.

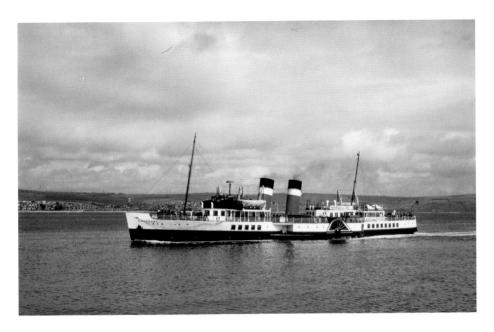

Waverley arriving at Weymouth on 23 May 1979. By the late 1970s the paddle steamer *Waverley* made her first visit to the south coast and visited the old Cosens piers at Weymouth and Bournemouth. The arrival of *Waverley* enabled a new generation, as well as older enthusiasts, to take a nostalgic journey back to the fondly remembered cruises of *Consul*, *Embassy* and *Monarch*.

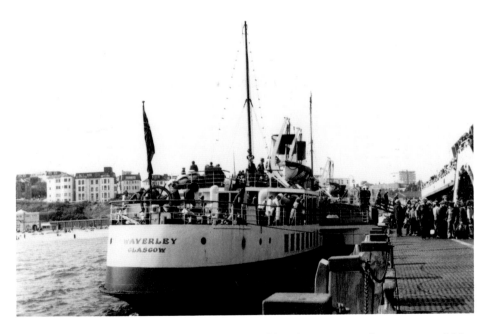

Waverley alongside Bournemouth Pier on one of her first visits to the resort on 16 May 1978. It must have been a dream for paddle steamer enthusiasts when they saw a steamer arrive at the pier once again.

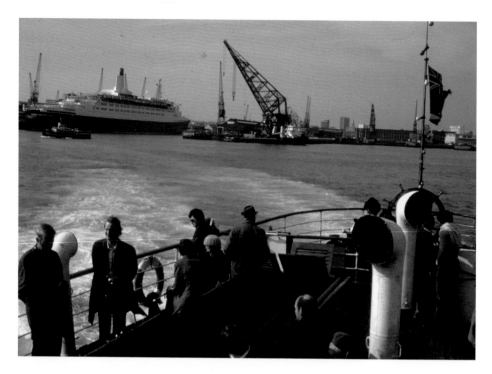

Waverley on a cruise in Southampton Water in 1979. The *Queen Elizabeth II* can be seen in the distance.

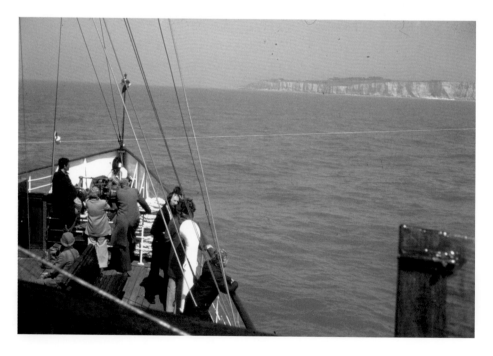

A view from *Waverley*'s bridge in 1982 with Ballard Down in the distance.

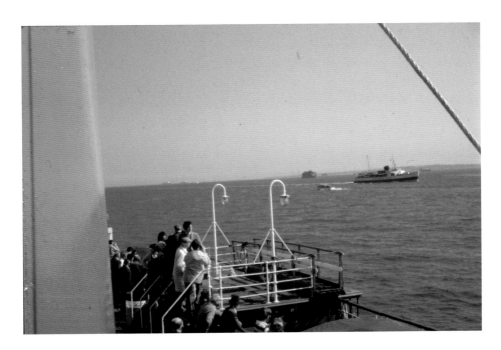

Waverley cruising in the Solent in 1980 with the Portsmouth to Ryde ferry *Southsea* in the distance.

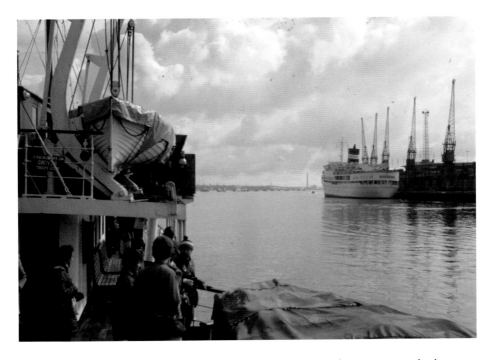

The *Uganda* viewed from the deck of *Waverley* in 1979. Over the years *Waverley* has seen a large number of ocean liners disappear from Southampton. These have included the *Canberra* and the *QE2*.

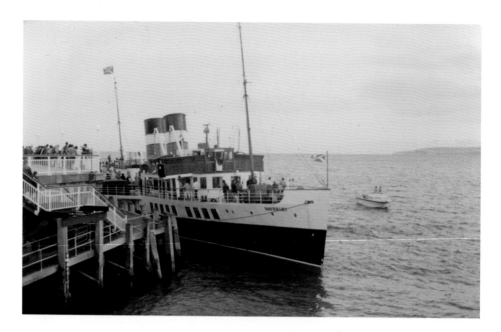

The famous *Waverley* alongside Bournemouth Pier in September 1986. The resort remains a popular and important calling point for *Balmoral* and *Waverley* in the twenty-first century. *Waverley* has undertaken many exciting cruises from Bournemouth. These have included Kingswear on the River Dart in Devon.

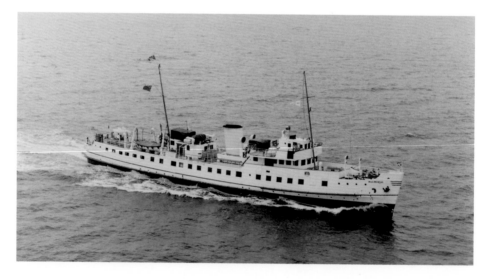

After her service with Red Funnel and P&A Campbell, *Balmoral* faced an uncertain future and static use seemed to be her best option. By the 1980s the success of the *Waverley* meant that a consort was urgently needed to provide a backup in case of breakdown, as well as providing much-needed extra usage of piers and harbours to make them economically viable. *Balmoral* provided the perfect answer and took up her role as consort to *Waverley* in 1986 in her smart new livery shown here.

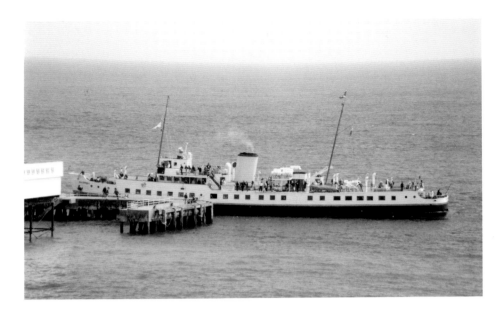

Balmoral at Sandown Pier in June 1995. By that time *Balmoral* had firmly established herself as a worthy consort to the *Waverley* and had developed a timetable that saw her visit many old haunts such as the Isle of Wight, Dorset and Hampshire.

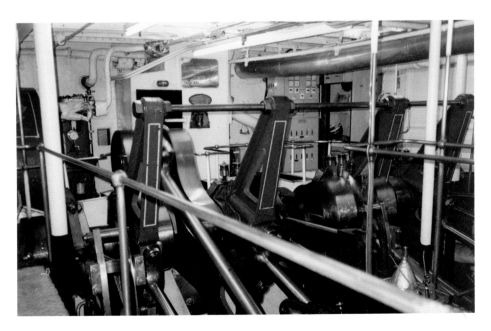

Waverley's impressive steam engine. Her engine room remains open to passengers to view from behind a barrier. This carries on a tradition that dates back to Victorian times. The engine room provides a rare glimpse into the past when steam engines were commonplace.

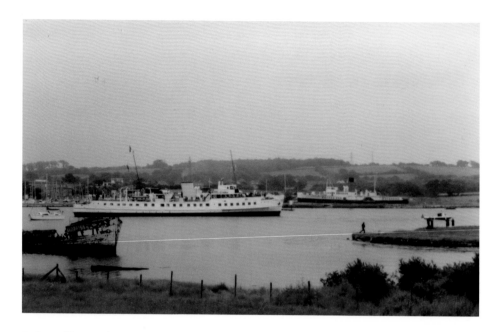

Balmoral has undertaken a wide range of cruises along the south coast and on the Isle of Wight since she began her preservation career. This view shows her on a special cruise in the early 1990s up the River Medina on the Isle of Wight to view the *Ryde* in her mud berth at Binfield Marina.

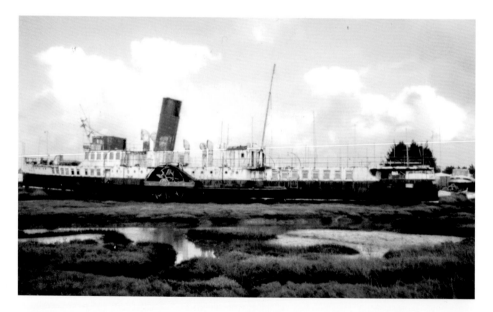

Ryde has now spent as long out of service as she spent in service. The decades since the 1960s haven't been kind to her. Initial positive years as a venue at Binfield on the Isle of Wight along with the *Medway Queen* soon gave way to a steady decline. Inevitably, once corrosion and rot took control, the cost of restoring her has become prohibitive and *Ryde* has declined even further to the point where she has little chance of being restored.

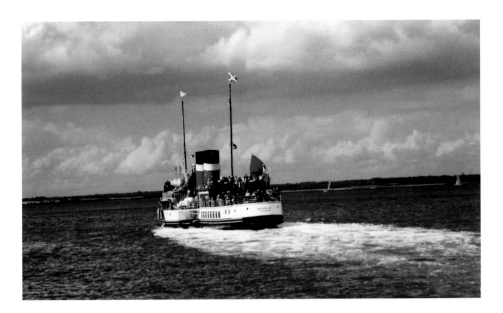

Waverley has undertaken around three weeks of cruises each year along the south coast since the late 1970s. These cruises have mainly focussed on the old pleasure steamer calling points of Southampton, Portsmouth, Bournemouth, Weymouth, Swanage and the Isle of Wight.

Publicity material for *Waverley* in 2014. She, along with the *Balmoral*, keeps the great tradition of coastal and river cruising alive along the south coast.

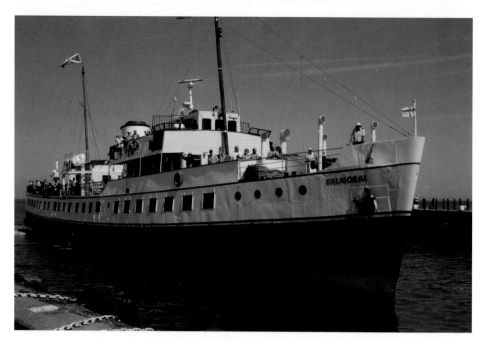

Balmoral is now the last of the south coast pleasure steamers. She is the last classic Red Runnel vessel and one of the final few survivors of the 1953 Coronation Fleet Review.

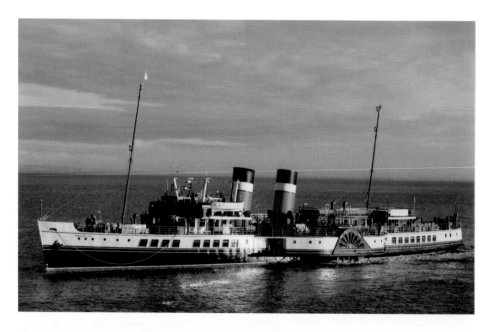

The pleasure steamers *Balmoral*, *Kingswear Castle* and *Waverley* keep alive the great tradition of pleasure steamer cruising started by Cosens over a century earlier. By doing so, they enable the present generation to enjoy the simple pleasures of a pleasure steamer that were so beloved of our forefathers on the 'Buff Funnel Fleet'.